dust for fear that the landing module would be swallowed up as if in quicksand (e.g., Gold 1962); the terrain was imaged and pored over in a fine-grained detail that would have left Galileo giddy.

While there was still some faint possibility that the Moon sheltered microbial life (the astronauts were quarantined on their return in case they introduced an interplanetary plague), the process was as deadly to the Moon as the fake chemical erosion invented by *The Times-Dispatch*. Firstly, the development of lunar science cemented the idea of the Moon as a static body, unchanged and unchanging. Then the astronauts walked the surface, sending back photos that looked to be taken in black-and-white film, but were actually in colour, so little of it there was. We saw through our own eyes the grey regolith (the broken rock and dust covering the bedrock), the black shadows, and the blackness of the sky, deeper than the void. The starry lunar night seen by the astronauts did not appear in these photos due to exposure times. Having been stripped of life, the Moon now was denied its own beauty.

The astronauts themselves did not necessarily feel this. Neil Armstrong said the Moon had "a stark beauty all its own. It's like much of the high desert of the United States" (Phillips 2014). Astronaut Alan Bean, after his return from the Apollo 12 mission in late 1969, used his painting skills to portray a distinctly lunar palette of muted mauves and yellows. Talking with lunar scientist Phil Metzger, Bean said he did not find the Moon to be a monotone place: it had its own colours and textures (Gorman 2019, 179).

Nonetheless, the perception of the Moon as a long-dead world inimical to life had taken hold in the popular imagination. The idea of the death of a celestial body was based on a contrast to the Earth as "alive," aided by the iconic *Earthrise* photograph taken in 1968, and in contrast to earlier conceptions of the Moon as part of a cosmology where everything in the heavens partook of "life" in some way. Science and the cultural associations of colour had conspired together to suck the life out of the Moon.

what's at stake—lunar mining

None of this would matter if capitalism had not been victorious at the end of the Cold War. In the ideological vacuum left by the cessation of competition for the Moon, a slow creep started.

The success of the Apollo 11 mission made the Moon less critical as an ideological weapon in this war, and for over fifty years there were no further plans for human missions. In space gatherings all over the world, people debated "Moon or Mars?," the question being whether the Moon should be bypassed in favour of throwing all resources toward the next human missions to the "red planet."

In the meantime, changes were afoot. In the 2000s, space agencies such as NASA moved to a model of outsourcing technology and missions to private industry. Space billionaires declared that their wealth would be used to support their boyish ambitions of high tech and space travel. From merely capitalist, the overall tenor of the space world became hyper-capitalist, treating the exploitation of space resources as inevitable. The original UN space treaty provisions about sharing the benefits of space exploration with all humanity were reframed as a disincentive for potential investors. The investor, rather than the astronaut, became the new "envoy of all humanity."

In the span of a decade or so, the debate died. It was no longer "Moon or Mars?" It was Moon *and* Mars, with the former viewed as a test bed for technology and governance. It became a sacrificial lamb to protect possible life on Mars. The Moon was dead and on its corpse the space billionaires started planning their conquest of the solar system. If one questioned this premise publicly, the predominantly white, male Musk bros and suburban scions of colonialism became angry. Not just annoyed, *angry*. As if a living Moon was a personal insult, an assault on their masculinity.

permanently shadowed regions

One reason for the change of direction was that recent studies had shown that the Moon did, in fact, have resources that could support life. In 2008, data collected by India's Chandrayaan 1 lunar orbiter provided evidence that deep craters in the permanently shadowed regions (PSRs) at the lunar south pole were full of a substance more precious than diamonds: water ice. Water and oxygen derived from the ice could be consumed by humans, but this was not the real drawing card. It could also be used to make rocket fuel, powering a local lunar economy and enabling the long trip to Mars. However, the discovery of water, usually considered a prerequisite for life, did not change the entrenched perception of death. The water was neutralized in ice, a potential not yet realized.

The reason the water ice survived was because it was shielded from the heat of the Sun by permanent shadows. For two billion years, only starlight and zodiacal light—the light of the Sun reflected through interplanetary dust—reached the surface of the ice lakes in the craters. Let that sink in: shadows two billion years old. On Earth, the polar regions have six months of light alternating with six months of darkness, with periods of twilight at the changing of the seasons. We do not have such permanent shadows, unless it is in the mouths of deep caves where the lack of light is simply darkness.

As intangible as they are, these shadows seem to me to have intrinsic value. They are among the oldest shadows in the solar system. As a landscape type, such permanently shadowed regions are rare. They are known on the dwarf planet Ceres in the asteroid belt, and on Mercury, where it is thought they also harbour water ice and other volatiles.

Just as the Sun never penetrates the shadows, there are also areas of the south pole that are never (or rarely) in darkness. They are called the peaks of eternal light, recalling Dante's symbol of spiritual apotheosis in the *Divine Comedy* (Daigle-Williamson 2015). The lunar night is savage, with temperatures falling to -130 degrees Celsius. The peaks offer refuge from the cold and an uninterrupted source of solar power for the deep ice mines to come.

Numerous missions are now planned to the PSRs. India's Chandrayaan 3 mission landed close to the south pole in 2023, closely following a failed Russian landing attempt. The NASA Artemis 3 mission to send the first woman to the Moon will land somewhere in the south pole PSR (Speck 2022). Orbiters and rovers are going to prepare the way for industrial infrastructure and habitats in the borderlands between light and shadow.

Inside the shadows, lunar ice miners will work in artificial light just as they do underground on Earth. It won't, most likely, be with drills, blasts, and ice picks. Thermal mining is a technique where the ice will be vaporized, the gas collected and then refrozen to allow for transport and processing (Sowers and Dreyer 2019). The business case for extracting profit along with the ice has already been made. The shadows will swim back to fill the voids left when the lights are turned off. But will they be the same? The two-billion-year reign of darkness will have ended.

How do you rehabilitate a shadow?

what we do in the shadows

The PSRs are a unique landscape that illustrate how natural heritage intersects with cultural heritage. Before, they were simply a neutral, if notable, landform. Now that they have been established to have utility for humans, they are being overwritten with economic and scientific values. But that doesn't seem enough, not for me, anyway. The ancientry, coldness, and power of the dark ice craters is not part of this story, and I think it should be.

The quality of shadows on the Moon is very different to those on Earth. Sunlight reflected from the Moon's gently rounded terrain provides some feeble illumination inside the shadow, as does earthshine, which is a secondary source of light in lunar skies. But without direct sunlight and atmospheric refraction, the depths of shadows are pitch-black, and inside them, the temperature drops radically.

The evolution of my thinking about lunar shadows started with NASA's 2011 guidelines on heritage protection on the Moon. The guidelines propose that buffer or exclusion zones be placed around US sites to protect them from the impacts of dust abrasion during future surface activities. The buffer proposed for Apollo 11 was a circle with a radius of fifty metres. I wondered if this would encompass all parts of the site, and this made me realize that the shadows cast by the hardware abandoned there were also part of the "fabric" of the site.

In searching through the archive of Apollo images, I was very struck by those in which the astronauts appear only as shadows in the photograph they or another crew member are taking. They reminded me of a series of paintings by the Italian artist Giorgio de Chirico in the 1910s. These paintings featured empty urban landscapes with colonnades, towers, and statues casting shadows at odd angles (e.g., *L'enigme du jour* [1914]—see Hollier 1994). They are stark and stylized. Art critics say the use of light and colour evokes melancholy, or even despair. Similarly, the Apollo images, with the silent shadow astronauts stalking on elongated legs, seems to amplify the loneliness of landscape.

When the astronauts left, nothing moved on the lunar surface—but the shadows are still a dynamic part of the site. As the lunar day rolls by, the shadows circle around the object that cast them, like sundials. They are both part of the natural environment and cultural objects. They contribute to the aesthetic significance of the site that is created by the distinct lunar surface and light. Lunar rocks are irregular in shape, but the human-made

shadows are clean lines and angles, or lacy anemones filtered through mesh antennas. Some shadows lie on the surface while others, such as those cast by the ridges on the soles of the astronauts' overshoes, are embedded in the regolith. Underneath and around the hardware is an intangible "shadow site."

The shadows have a symbolic resonance on Earth, as they are a beloved tool of lunar conspiracy theorists to argue that the Apollo landings were filmed in a movie studio. Others have explained the complex reasons why we might not be able to rely on terrestrial experience when using off-Earth shadows as a truth-telling tool (Perlmutter and Dahmen 2008; Platoff 2011). These evanescent effects of light are a battleground of ideologies, signs from which the truth can be read.

Compared to the young shadows of human traces, the shadows of the PSRs are unbearably ancient for something that doesn't technically exist. Their value lies in this continuity. They don't care about us: they lie in "Craters of indifference to human time," as the poet and lunar environmentalist Ceridwen Dovey phrases it (in Dovey and Potts 2020). For all this anciently and power, however, they are still vulnerable to human predation. Two billion years of darkness can be broken in a moment, and surely this moment should not be taken lightly.

In the PSRs, the shadows both create and conceal treasure from the human gaze. They are an active force in trapping and freezing the water: the ice lakes are a result of their interaction with the complex lunar environment. The craters that cast them have names; perhaps we should give the shadows their own names to acknowledge that their intangibility translates into something more substantial, so much so that it has excited the cupidity of the lunar capitalists.

The Dantean symbolism in which degrees of light represent closeness to heaven, with hell in the pit of darkness, seems apt to describe the contrast between the peaks and crater depths. The temperature range from light to dark is from about -50 degrees Celsius, which is Antarctic-level bearable, to -130 degrees Celsius in the pits. The crater ice lakes resemble the lowlands "where the sun is silent" in *The Inferno*, whence Dante escapes to begin his journey upward (canto 1; Longfellow 1904). The first circle of *Paradiso* is the Moon, which Dante observes is "much like a diamond that the sun has struck": the peaks of eternal light. Here, Beatrice offers to Dante "a new form, light so living that it trembles in your sight" (canto 2). Perhaps it is not that the Moon is dead, but that our vocabulary of planetary light and shade has not yet developed enough to do it justice.

wasteland & wilderness

Just as Dante gives us a symbolic vocabulary of light, T. S. Eliot's iconic modernist poem *The Waste Land* (1922) presents a symbolism of water. As Piechucka (2009) argues, aridity and sterility are strongly linked in the poem. It is notable that Eliot makes rock and water categories of mutual exclusion in the wasteland: "Here there is no water only rock / . . . mountains of rock without water." Without water, the wasteland is inimical to life: "Dead mountain mouth of carious teeth that cannot spit." However, such a perceived lack of resources is sometimes what protects a landscape against the depredations of human exploitation.

On Earth, places seemingly untouched by human hands, like the icefields of the Antarctic or the Namib Desert, are given value. Such landscapes are designated wildernesses worthy of the benevolent protection of wealthy nations, who hold the power to preserve or destroy them. They are also often ideological battlefields, where Indigenous rights come up against the capitalist interests of mining companies; and environmentalists seek to evict the people whose long agency had shaped the landscape declared "pristine" (Fletcher et al. 2021; Pickerill 2008). The wilderness stands in opposition to urban, industrial, and agricultural landscapes.

The Moon's death has deprived it of the opportunity to be perceived as a wilderness in the eyes of many. By this standard, there is nothing there to preserve or maintain. However, it does have the potential to become a wasteland. The Wikipedia article on lunar resources states that the goal of sustainable development on the Moon is to "ensure that future generations are not faced with a barren lunar wasteland by wanton practices."[3]

Human activity transforms landscapes into "wastelands" when resources have been depleted and ecosystems destroyed. As the residue of industrial processes, the wasteland has no further potential to be exploited or "improved." Its natural values have been extinguished, leaving only scars and industrial detritus. The wasteland is vividly evoked in J. R. R. Tolkien's (1955) description of the destruction wrought by warfare on the plain of Dagorlad, a grey landscape of smoking dust cones, poisonous oil sumps, and noxious airs where nothing can live.

These oppositions are firmly grounded in a subset of economic and environmental beliefs held in contemporary Western capitalist societies. They are not universal among the humans for whom the Moon is supposedly a province or common heritage, as stated

in the UN outer space treaties (see this volume's appendix). As Chang (1992, 852) has expressed it, "The core of the Western environmental movement is derived from the present stage of the wasteland. It is not a movement derived from the different world views of indigenous [*sic*] persons, such as Native Hawaiians, who hold completely different attitudes towards scarcity and human influence on nature."

Space industry has a deep entanglement with wastelands. Early launch sites were located in places seen as unproductive and with low populations, such as the forests of French Guiana or the deserts of Woomera in South Australia and White Sands in the United States. This was very much not how these lands were perceived by their traditional owners. Kokatha people knew how to find water in the desert by observing vegetation and soil patterns, while the rocket range required the building of an expensive pipeline to supply the engineers and their families (Gorman 2005).

The Moon doesn't quite fit into either category. It is not wilderness, but it is not yet wasteland—this is a state that may lie in its future, a planet laid waste and abandoned when it no longer serves a purpose as a launch site for Mars, or as a source of minerals valued or scarce on Earth. The mission of lunar sustainability advocates is to postpone this moment for as long as possible. This is not the epitome of ethical and sustainable behaviour it might seem. If the Moon is already dead, how can it die further?

why the moon lives

To finish, I want to present some arguments about why the Moon should not be perceived as dead. An aspect of this is that, unlike the rapid erosion of the lunar surface presented in "The Man in the Moon Is Dying!," some change happens at a pace far slower than our short and frenetic human lives. We judge the Moon by standards it cannot meet, without plate tectonics, vulcanism, and atmosphere. This does not seem like environmental justice to me.

The Moon is currently in the Copernican or Neolunarisian geological age (Guo et al. 2014), which began roughly around eight hundred million years ago and is characterized by craters with bright rays, such as Tycho. In earlier periods the Moon had much more active vulcanism. In this latest phase, the lunar surface is shaped by external forces such as impacts with cosmic rays, micrometeorites, and meteorites. Already human activity is making its own contributions with the impacts of rocket bodies.

This process, which is common on the airless bodies of the solar system, is known as impact gardening. The surface is continually reworked, and ejecta from the impacts is redistributed to other regions. Despite appearances, the lunar surface is in a state of constant renewal. Impact gardening also plays a role in the formation and trapping of water on bodies like the Moon, Ceres, and Mercury (Costello et al. 2020).

Unlike Eliot's wasteland, the Moon has water cycles. Outside the magnificent structures of the polar ice lakes, there is a small-scale and daily creation and dissolution of water molecules in the minute craters caused by micrometeorite bombardment. We hardly know anything about this yet; but it clearly forms part of a larger water ecosystem that, apart from its benefits for human use, is part of a dynamic abiotic ecology (Honniball et al. 2021; Jones et al. 2018; Reiss et al. 2021).

On the surface, particles and rays interact directly with the regolith. Cosmic rays create the helium-3 that so interests humans as a potential power source; micrometeorites strike and melt the dust into shards of obsidian. The dust becomes electrostatically charged and sticky from this bombardment; for the Apollo astronauts it was a nuisance and health hazard, capable of causing equipment failure, lung injury, and seal erosion (Zakharov, Zelenyi, and Popel 2020). But let's reconfigure it from a nuisance to a planetary-scale ecology, responding actively to disturbance by flowing and sticking to moving bodies, even using them for transport off-planet. Inanimate, perhaps; but not without agency as it elicits a reaction from those in contact with it.

The dust has its own unearthly taxonomies. Hidden underneath the surface are microscopic towers and buttresses dubbed fairy castles, created by the static electricity that attracts and repels dust particles with equal measure (Hapke 1967; Szabo et al. 2022). Every bootfall of an Apollo astronaut crushed these sublunarian aerial formations. The fairy castle structure affects how light is reflected from the surface.

I've already spoken of the shadows, but lunar light is equally dynamic. Since the sixteenth century, Earth-based observers have seen what are known as transient lunar phenomena (TLP): "Glows, hazes, mists, brief colour changes and temporary obscurations of lunar surface features" (Hughes 1980, 438). There does not seem to be a single consistent explanation for all TLP characteristics, although outgassing in crater regions certainly accounts for a large proportion of them (Crotts 2009). Discussing the TLP, Hughes (1980, 438) says, "Three thousand million years is a long time for the Moon to be quiet and cold, but is it completely dead? Probably not, is the most reasonable answer."

Colour, then, is less uncommon on the Moon than we might think; but our insistence on correlating colour and life may be at least partially a result of prioritizing human senses such as vision, evolved for terrestrial circumstances. Maybe our eyes don't suit the Moon. Other Earth animals, with fewer cones for colour perception and more rods for light perception, live in a visual world that is no less rich than ours. On the other hand, human eyes are not even the pinnacle of colour perception. The mantis shrimp is known for having the most complex eyes and sophisticated vision in the world of the eyed, with sixteen photoreceptors as opposed to the human three, and the ability to see polarized and ultraviolet light (Cronin et al. 2022). We can only guess at the shades that different eyes might distinguish in the shadowed realms of the lunar surface. And we haven't even started on the acoustic landscape.

The Moon seems dead because we haven't learned to see it as alive. But we are surrounded by decay and death on Earth, and on the Moon we would be the ones bringing death, already introduced with the dead plants on China's Chang'e 4 lander. Imagine if the dominant paradigm of lunar engagement were not a hyper-capitalist, post-Enlightenment dead cosmos with military men writing the script. Along with developing "other forms of knowledge, helped along by a subtle shift in descriptive language," Dovey (2021) urges that we should develop an ethics of kinship rather than of possession.

We would see similarity, not difference, and develop a palette of grey that we would read intimately as we do now the terrestrial landscape, each nuance, each shadow giving meaning. We could navigate by the shadows and travel with the terminator, the dividing line between day and night; and at night, stand with our sister Moon to see the stars with a clarity that only comes by facing the void full on: unafraid and joyful.

notes

1. "The Great Moon Hoax of 1835," *Museum of Hoaxes*, accessed July 20, 2024, https://hoaxes.org/text/display/the_great_moon_hoax_of_1835_text/P5.

2. "The Man in the Moon Is Dying!," *Strange Ago*, July 6, 2017, https://strangeago.com/2017/07/06/man-moon-dying/.

3. Wikipedia, s.v. "Lunar Resources," last modified June 3, 2024, 08:10, https://en.wikipedia.org/wiki/Lunar_resources.

bibliography

Chang, Williamson B. C. 1992. "The 'Wasteland' in the Western Exploitation of 'Race' and the Environment." *University of Colorado Law Review* 63: 849–70.

Costello, E. S., R. R. Ghent, M. Hirabayashi, and P. G. Lucey. 2020. "Impact Gardening as a Constraint on the Age, Source, and Evolution of Ice on Mercury and the Moon." *Journal of Geophysical Research: Planets* 125 (3): e2019JE006172.

Cronin, T. W., M. L. Porter, M. J. Bok, R. L. Caldwell, and J. Marshall. 2022. "Colour Vision in Stomatopod Crustaceans." *Philosophical Transactions of the Royal Society B Biological Sciences* 377 (1862): 20210278.

Crotts, Arlin P. S. 2009. "Transient Lunar Phenomena: Regularity and Reality." *Astrophysical Journal* 697 (1): 1–15.

Daigle-Williamson, Marsha, 2015 *Reflecting the Eternal: Dante's Divine Comedy in the Novels of C. S. Lewis*. Peabody, MA: Hendrickson Publishers.

Dovey, Ceridwen. 2021. "Making Kin with the Cosmos." *Center for Humans and Nature*, April 11, 2021. https://humansandnature.org/making-kin-with-the-cosmos/.

Dovey, Ceridwen, and Rowena Potts. 2020. *Moonrise*. Video. http://www.moonrisefilm.com/.

Fletcher, M. S., R. Hamilton, W. Dressler, and L. Palmer. 2021. "Indigenous Knowledge and the Shackles of Wilderness." *Proceedings of the National Academy of Sciences* 118 (40): 2022218118.

Galilei, Galileo. 1610. *Sidereus Nuncius*. Venice: Thomas Baglioni.

Gee, E. 2020. *Mapping the Afterlife: From Homer to Dante*. Oxford: Oxford University Press.

Gold, T. 1962. "Processes on the Lunar Surface." *The Moon* 14: 433–40.

Gorman, A. C. 2005. "The Cultural Landscape of Interplanetary Space." *Journal of Social Archaeology* 5 (1): 85–107.

———. 2015. "Let the People Decide New Place Names on Mercury and Pluto." *The Conversation*, April 20, 2015. https://theconversation.com/let-the-people-decide-new-place-names-on-mercury-and-pluto-40079.

———. 2019. *Dr Space Junk vs the Universe: Archaeology and the Future*. Sydney: NewSouth Books.

Guo, Dijun, Jianzhong Liu, Li Zhang, Jinzhu Ji, Jingwen Liu, and Liang Wang. 2014. "The Methods on Lunar Geochronology Study and the Subdivisions of Lunar Geologic History." *Earth Science Frontiers* 21 (6): 45–61.

Hapke, B. 1967. *Photometric and Other Laboratory Studies Relating to the Lunar Surface*. NASA contractor report, NASA-CR-89078. https://ntrs.nasa.gov/citations/19670028868.

Hollier, Denis. 1994. "Surrealist Precipitates: Shadows Don't Cast Shadows." Translated by Rosalind Krauss. *October* 69: 110–32.

Honniball, C. I., P. G. Lucey, S. Li, S. Shenoy, T. M. Orlando, C. A. Hibbitts, D. M. Hurley, and W. M. Farrell. 2021. "Molecular Water Detected on the Sunlit Moon by SOFIA." *Nature Astronomy* 5 (2): 121–7.

Hughes, David W. 1980. "Transient Lunar Phenomena." *Nature* 285 (5765): 438.

Jones, B. M., A. Aleksandrov, K. Hibbitts, M. D. Dyar, and T. M. Orlando. 2018. "Solar Wind–Induced Water Cycle on the Moon." *Geophysical Research Letters* 45 (20): 10,959–67.

Kalachanis, K., E. Theodosius, and M. S. Dimitrijević. 2018. "Anaxagoras and His Contributions to Astronomy." *Astronomical and Astrophysical Transactions* 30 (4): 523–30.

Lewis, C. S. (1938) 1968. *Out of the Silent Planet*. London: Pan Books.

Longfellow, Henry Wadsworth. 1904. *The Divine Comedy* [translation]. Boston: Houghton Mifflin.

Nilsson, M. P. 1940. "The Origin of Belief among the Greeks in the Divinity of the Heavenly Bodies." *Harvard Theological Review* 33 (1): 1–8.

Perlmutter, D. D., and N. S. Dahmen. 2008. "(In)visible evidence: Pictorially Enhanced Disbelief in the Apollo Moon Landings." *Visual Communication* 7 (2): 229–51.

Phillips, T. 2014. "Wide Awake on the Sea of Tranquillity." NASA, July 9, 2014. https://www.nasa.gov/missions/apollo/apollo-11/wide-awake-on-the-sea-of-tranquillity/.

Pickerill, Jenny. 2008. "From Wilderness to WildCountry: The Power of Language in Environmental Campaigns in Australia." *Environmental Politics* 17 (1): 95–104.

Piechucka, Alicja. 2009. "'The River Is Within Us, the Sea Is All About Us': Symbolist-Inspired Water Motifs in T. S. Eliot's Verse." *Acta Universitatis Lodziensis. Folia Literaria Anglia* 8: 43–58.

Platoff, Anne M. 2011. "Six Flags Over Luna: The Role of Flags in Moon Landing Conspiracy Theories." Paper presented at the 24th International Congress of Vexillology, Washington, DC, August 1–5, 2011. https://escholarship.org/content/qt5h31r40r/qt5h31r40r.pdf.

Reiss, P., T. Warren, E. Sefton-Nash, and R. Trautner. 2021. "Dynamics of Subsurface Migration of Water on the Moon." *Journal of Geophysical Research: Planets* 126 (5): e2020JE006742.

Russell, W. M. S. 1983. "Life and Afterlife on Other Worlds." *Foundation* 28: 34–56.

Sowers, George F., and Christopher B. Dreyer. 2019. "Ice Mining in Lunar Permanently Shadowed Regions." *New Space* 7 (4): 235–44.

Speck, Emilee. 2022. "NASA Astronauts Will Land in Shadowed Regions on the Moon's South Pole." *Fox Weather*, August 19, 2022. https://www.foxweather.com/earth-space/lunar-home-base-nasa-astronauts-will-land-in-one-of-these-regions-on-the-moon.

Szabo, P. S., A. R. Poppe, H. Biber, A. Mutzke, J. Pichler, N. Jäggi, A. Galli, P. Wurz, and F. Aumayr. 2022. "Deducing Lunar Regolith Porosity from Energetic Neutral Atom Emission." *Geophysical Research Letters* 49 (21): e2022GL101232.

Tolkien, J. R. R. 1955. *The Return of the King*. London: George Allen and Unwin.

Zakharov, A. V., L. M. Zelenyi, and S. I. Popel. 2020. "Lunar Dust: Properties and Potential Hazards." *Solar System Research* 54 (6): 455–76.

noreen humble

voyages to the moon:
lucian & his legacy

In her contribution to this volume, Alice Gorman, with stark clarity, outlines the widespread perception of the Moon as dead, a near wasteland ripe for capitalistic exploitation. While this image does not solely belong to the period following the lunar landing of 1969, it was certainly reinforced by that event within the parameters of the colonialist mindset of the dominant players in the space race.

Just as from our earthly perspective we appear unable to grasp the time scale of natural forces at play on our Moon and how our presence, in exploitative form or not, alters these, so, too, from our anthropocentric viewpoint, have we forgotten that for much of the past, and still for many non-Western non-colonial cultures in the present, the Moon, and indeed the other planets, are living entities, often deities. In the ancient Greek tradition, which is effectively behind all Western narratives and mythologizing, the Moon is a goddess, Selene, and part of her mythology is that she falls in love with a mortal but endlessly sleeping youth, Endymion, who in some versions of the myth is the discoverer of the course of the Moon, and in others becomes the king of the Moon.

But while our imagination fails us in these ways, at no time has any amount of hard science, whether attained through the naked eye, increasingly powerful telescopes, satellite imagery, or moonwalks, constrained imaginary speculation about journeying to the Moon or colonizing it. Though imaginary voyages are by no means centred on the Moon alone, the Moon is the closest planetary body, and it is to the Moon that the first imaginary space journeys in the Western tradition go. The earliest of these journeys are found in two works of the ancient Greek author Lucian of Samosata (ca. 125–180 CE): *Icaromenippus* and *True Histories*. These works are striking not least for their imaginative power, their engagement with contemporary scientific knowledge, and their satirical force, but also for the depth and longevity of their influence on virtually all imaginary lunar voyages until at least the early twentieth century. Their reception history is rich and complex so what follows are just a few representative highlights of the long influence of these early imaginings.

ancient greece: setting the scene

Lucian's *Icaromenippus* and *True Histories* date to the second half of the second century CE.[1] They do not appear in a vacuum. Two Greek works that predate them were undoubtedly important sources. The first is a novel by Antonius Diogenes entitled *The Incredible Things beyond Thule*. Though it is now lost, we have a summary of it preserved in a ninth-century encyclopedic work, the *Bibliotheca* of Photius (ca. 810–893), and so know that embedded in it was an imaginary trip to the Moon.[2] The second is the still extant dialogue *On the Face of the Moon* by the ancient Greek biographer and philosopher Plutarch (a work composed likely in the early second century CE).[3] There is no imagined voyage to the Moon in Plutarch's work, but in the course of the lengthy dialogue all contemporary scientific knowledge (astronomical, cosmological, geographical, and catoptrical) about the Moon is discussed. The topics range across the nature of its topography (e.g., it is argued that it is full of mountains and valleys), its substance, velocity, phases, eclipses, etc., filtered through a variety of different philosophical outlooks as represented by the different interlocutors. The dialogue ends with a lengthy myth explaining that the purpose of the Moon is as a halfway house during the life cycle of souls. Part of the discussion also turns to speculation about whether or not the Moon is inhabited, during which expression is given to the hypothesis that if there are inhabitants, from their point of view, "they would be much more astonished that the Earth—looking at it as the dregs and dirt of the cosmos, glimpsing through moisture, steam and clouds as an unlit, low and immobile place—might generate and nourish living beings that take part in motion, breathing and warmth."[4]

Since 1969 it is no longer possible for us to un-know what it is like to see the Earth from the Moon,[5] but this conjuring of the lunar perspective of Earth has been a feature of speculations about and imaginary voyages to the Moon from the start, and Plutarch no less than Lucian remains an important touchstone for all the works discussed below.

Lucian's two lunar voyages are different in every possible way. The shorter of the two, the *Icaromenippus*, is a dialogue between one Menippus and an anonymous friend.[6] It, like many of Lucian's works, is a satire, here poking fun at philosophers and the wild excesses of scientific speculation of the day concerning the Moon. Tired with the trivialities of life on Earth, Menippus assembles a pair of wings from an eagle and a vulture so that he can find the answer to such questions as what the Sun was, why the Moon changed shape, etc. Upon reaching the Moon he turns his gaze upon the Earth, but it is so small that he despairs about being able to see it properly, until the philosopher Empedocles appears (all burned up, having thrown himself into Mount Aetna) and reveals to him that if he flaps his eagle's wing he will soon find he has the sight of an eagle. He is then able to see human hypocrisy in all its forms, relating all manner of behaviours, mostly unsavoury, and noting how overwhelming it is to take in the spectacle of the world all at once. This lengthy reflection on what is happening on Earth recalls but greatly expands upon Plutarch's brief lunar perspective on our world.[7] As Menippus is about to leave to fly farther to the realm of Zeus, the Moon speaks to him about the slanderous ways the philosophers talk about her, and asks him to get Zeus to do something about this. Menippus flies off, then, to the realm of Zeus, reports his and the Moon's complaints, and the assembly of gods agree to annihilate all the philosophers—*after* the festival season, so that they get the benefit of all the sacrificial offerings first.

While in the *Icaromenippus* the focus is on viewing the Earth from the Moon, the opposite is the case in the *True Histories*, where a much more elaborate journey to a richly inhabited Moon is imagined as part of a series of fantastical adventures that the protagonists undergo (for a complete translation of the journey, see Keith Sidwell's contribution to this volume). This, too, is a deeply satirical work. Travel narratives are certainly the main focus of the satire, but few poets, historians, philosophers, and scientists are exempt from attack. The broader narrative begins with the narrator and fifty companions setting off on a sea journey toward the Pillars of Hercules (the promontories that flank the entrance to the Strait of Gibraltar). Blown off course, they begin their fantastical journey. They first encounter rivers of wine, and when investigating the source come across the first of a number of hybrid creatures: vine-women. Those of the companions who succumbed to their charms were held fast by their genitals and grafted to them,

20 mythologies of outer space

becoming, likewise, grape-bearing vine-creatures. Departing from this place they are swept up by a whirlwind and soon they find themselves on the Moon, where they are at first captured by gigantic Vulture-Riders and brought to Endymion, the king of the Moon (the feminine Moon has no voice in this work; in fact the feminine is eschewed completely here, even for reproductive purposes). They are not treated badly and discover that Endymion is at war with Phaethon, the king of the Sun, over who gets to colonize the Morning Star—a critique of colonization thus finding a place already in this earliest of imaginary voyages.[8] The war is related. Phaethon is the victor and his postwar building of a cloud wall in the air causes an eclipse, until it is removed and peace established by a treaty. Not only do the armies of the two sides consist of monstrous hybrid creatures, but the inhabitants of the Moon are fantastical creatures who defy gender and sexual norms: the lunar inhabitants are all men, who gestate their children in their calves, and a race of tree-men live side by side with them, also androgynous with wildly imaginative reproductive means. No practices bear any resemblance at all to those on Earth. While the narrative is focused on the strangeness of life on the Moon itself, there is a brief description of how things on Earth can be seen and heard, here via a mirror positioned over a well. Though Endymion entreats the travellers to stay, laden with gifts they set out on their way again in their ship, finally setting down in the sea again after four days, where they are swallowed by a whale. Their fantastical adventures continue from there, the voyage to the Moon being only one portion of the whole work.

Together Lucian's journeys set the parameters for later imaginary voyages with the key elements being an elaborate framing story starting in the real world, the obligatory imagining of how the Earth looks from the Moon, gigantism, and the hybridity of creatures who live on the Moon. The strong critique of colonialism in the *True Histories* will manifest as a theme again in later journeys, though paradoxically not so much in those written during the wave of colonization in the early modern period.

16th century europe & the scientific revolution

There is a renewed interest in imagining voyages to the Moon in the wake of the Scientific Revolution, particularly after the publication in 1543 of Nicolaus Copernicus's (1473–1543) *De revolutionibus orbium coelestium* (*On the Revolutions of the Heavenly Spheres*). What these voyages might have looked like had the works of Plutarch and Lucian not also been, by this time, widely available in print, not just in Latin but increasingly in the major vernacular languages in Europe, is hard to say. Lucian was popular

both in schools and more generally. His satirical bent appealed greatly, so that a work like the *True Histories* was not just a model for wacky off-world journeying, but also for its mode of attack.[9] The fact that Erasmus's Latin translation of the *Icaromenippus*, first published in 1514, was reprinted fifteen times by the middle of the century played no small role in the dissemination of that work too. But even before the text or its translation was in print, the circulation of manuscripts of both in the fifteenth century ensured their influence was already being felt. The *Icaromenippus*, for example, is undoubtedly in Ludovico Ariosto's (1474–1533) mind when he composes a brief journey to the Moon in his *Orlando Furioso* (34.68–86), first published in 1516 (Mac Carthy 2009).

The most important of Lucian's direct successors in terms of combining science with a fantastical lunar voyage was Johannes Kepler (1571–1630). His *Somnium*, begun in 1593, was published posthumously in 1634.[10] The treatise proper is fairly short but accompanied by copious lengthy notes. Its purpose, Kepler says in the fourth note, "is to use the example of the Moon to build up an argument in favor of the motion of the Earth."[11] It starts by him falling asleep and dreaming of reading a book, composed by a fictional Icelandic astronomer, Duracotus, who relates a portion of his life story, starting with some adventures, which include learning about sidereal matters from the contemporary Danish astronomer Tycho Brahe. Upon his return home, Duracotus's mother tells him she has the ability to commune with the daemons of the Moon, here named Levania (based on the Hebrew, *Lebana*, which Kepler says he favoured over the Greek for its more occult flavour). A daemon then takes over as the narrator and first describes how a human could be carried to the Moon (showing Kepler's theorizing about the effects of gravity on the human body). There follows a description of the physical nature of the Moon, its climate, movements, etc., and how its inhabitants—who are of gigantic size but short-lived—would view the Earth and its movements. The narrative ends abruptly with Kepler awaking from his dream.

The extraordinary meshing of the supernatural framework with scientific knowledge in this work has long been noted. There is no doubt but that the gigantism of Lucian's Moon dwellers is a direct inspiration (Lambert 2002, 11), as is the elaborate set-up in the outer story. Indeed, in the second note on the text Kepler recounts how he chanced upon Lucian's *True Histories*, which he used to help him to learn Greek, and which were his "first steps in the trip to the Moon." He also notes the following: "at Prague, in the year 1604, I quoted extensively from Plutarch in my *Optical Part of Astronomy*." He is referring here to Plutarch's *On the Face of the Moon*, a work he himself translated into Latin.[12]

Kepler's work is not, however, like Lucian's, satirical, nor does it tap into the contemporary anxieties about colonization, and in these points it differs from the rest of the works discussed here. Its purpose is serious, even if the literary and fantastical framework of the lunar voyage owes much to Lucian. Further, the work did not circulate tremendously widely; the first German translation did not appear until 1898 and the first English translation came only in 1965.

The contrast with the translation history of Lucian's works couldn't be starker, or indeed with the translation history of the first English translunar voyage that appeared only four years after Kepler's *Somnium*: Bishop Francis Godwin's (1562–1633) *The Man in the Moone, or a Discourse of a Voyage Thither by Domingo Gonsales the Speedy Messenger* in 1638.[13] Godwin's composition was far less scientific than Kepler's *Somnium*, though it is fully conversant with contemporary scientific theories, but it was also far more successful as a literary work. Between 1638 and 1768 it was published twenty-five times across four languages (Parrett 2004, 50).

There is again an elaborate framing story involving the adventures of one Domingo Gonsales. After some years of exile, while on his way home to Spain, he finds himself on the island of St. Helena, where he discovers a type of wild swan that can carry heavy weights. When his journey resumes, he is attacked and escapes by taking to the air with his wild swans, who simply keep flying higher until he reaches the Moon after twelve days. His first observation is how huge the Earth looks from the Moon compared to the Moon from the Earth, his second how huge the trees are. He discovers a plant of surpassing deliciousness just before he is surrounded by people, first described as twice the height of Earth people, though the longer they live the huger they become. Unlike most other encounters with imaginary Moon inhabitants, this one is peaceful, though the trope of bringing the interloper to their leader is followed.

Godwin's vision of life on the Moon starts out looking like it might be utopian, but that image is soon problematized, not least by the description of another group of inhabitants termed "changelings." They are of ordinary height, thoroughly despised, and serve as slaves to the "genuine" gigantic lunar people. Any child of poor temperament is sent down to Earth in exchange for one of better temperament. This is a peculiar invention by any standard, but it is made all the more astonishing by the way Godwin casually links this practice to contemporary discourse about Indigenous peoples in the "new world":

> And their ordinary vent for them [the children they send away] is a certaine high hill in the North of *America*, whose people I can easily beleeve to be wholly descended of them, partly in regard of their colour, partly also in regard of the continuall use of Tobacco which the *Lunars* use exceedingly much, as living in a place abounding wonderfully with moisture, as also for the pleasure they take in it.

Here Godwin effectively doubly dehumanizes the Indigenous peoples of North America: not only are they inferior, they are not even human but defective, slavish lunar beings.[14]

Gonsales is eventually prompted to depart by constant recall of his family back in Spain and by the fact that his swans, his only means of transportation, start to die. He leaves, with gifts of magical stones, and lands in China nine days later, where some further adventures await him (just as Lucian had left the Moon with gifts from Endymion and embarked on further adventures).

Godwin was highly educated, and as has been well shown, his work draws on many different contemporary sources. In one of these, Richard Burton's *Anatomy of Melancholy* (first published in 1621), is the exhortation "with a *Galelies* glasse, or *Icaromenippus* wings in *Lucian*, command the Spheares and Heavens, & see what is done amongst them."[15] Godwin does the latter both literally—Menippus uses the wing of an eagle and the wing of a vulture to ascend to the moon, Gonsales uses wild swans, one of whose feet has talons like an eagle—and figuratively, with the elaborate framing story that starts in reality and slowly becomes more fantastical and with his continuing to people the Moon with gigantic creatures and plants. Godwin, like Burton, had read his Lucian.

19th & 20th century colonial perspectives from france & england

The next notable Moon voyages I want to look at that have links to Lucian belong to the late nineteenth and early twentieth centuries. Lucian was still readily available in print in all major vernacular languages and was a staple on school curricula throughout Europe and its colonies, and all the literary creators in this section were educated in Latin, and the first also in Greek.

In the mid-nineteenth century the bestselling French novelist Jules Verne (1828–1905) published *De la terre à la lune* (1865), followed five years later by its sequel, *Autour de la lune* (1870). Mankind does not actually land on the Moon in these works and their de-

tail focuses on contemporary technological capacity, specifically with regard to rocketry, so there is not so obvious a link to the Lucianic works here other than in the general sense that they both concern a fantastic voyage to the Moon and are satirical, critiquing both capitalism and colonialism. There are two reasons, though, for mentioning them: first, they were wildly popular and certainly influenced the two slightly later journeys I am going to discuss; secondly, they are sprinkled with references to the past—not to Lucian, but certainly to Plutarch, among other classical writers. For example, when one of the characters is asked whether he thought the Moon inhabited, he answers, "men of great intelligence, such as Plutarch, Swedenborg, Bernardin de St Pierre, and others have, if I mistake not, pronounced in the affirmative" (Verne [1874] 2019, 95). Verne, like his predecessors, acknowledges the tradition he considers himself to be writing within.

Nearly half a century later, in 1901, came the publication of *The First Men in the Moon* by H. G. Wells (1866–1946). Wells, like Verne, satirizes the colonial impulses of his day, but he does so in a far more allegorical and fantastical way. That fact alone puts him more firmly in Lucian's camp, but he also acknowledges the debt openly in two places. When later writing about the literary predecessors for what he termed his "scientific romances," he lists Lucian's *True Histories* (Wells 1933, vii), and, tellingly, the opening epigraph to his *The First Men in the Moon* is a quotation from the opening of Lucian's *Icaromenippus*.[16]

As is customary, Wells creates an elaborate outer story, which in this case leads a Mr. Bedford, an unscrupulous businessman, into the company of an earnest scientist, Professor Cavor, working on a substance, cavorite, that reflects gravity (in one of their early conversations Bedford mentions Verne's *A Trip to the Moon*; see Wells [1901] 2005, 28). Once this is perfected, they successfully voyage to the Moon. They find the environment harsh and challenging upon first stepping out of their capsule, but when day appears plants start growing at an extraordinary rate. That these plants turn out to be intoxicating is a nod to Godwin, as is the fact that the protagonists discover they can leap huge distances with little effort. They soon learn they are not alone: monstrous animals called mooncalves are being herded around by giant, five-feet-tall, ant-like creatures called Selenites.[17] Upon gorging themselves on the plants the voyagers fall into a drugged state, and the next thing they know they are underground, the captives of the Selenites. Bedford urges fighting, Cavor urges restraint. Bedford has his way and they eventually make it back to the surface, having ascertained that the mooncalves mine gold for the ant creatures. In the end Bedford gets back to the capsule and makes his way back to Earth with some of the gold, intent on making a profit out of all this, which, happily, he fails to do.

The last example of imaginary lunar voyaging showing direct Lucianic influence is the 1902 film *Le Voyage dans la lune* by Georges Méliès (1861–1938). While the immediate and general inspiration for Méliès's film is agreed to be Verne's and Wells's novels,[18] there are strong Lucianic elements to be found too. And like all his models, Méliès's uses his chosen medium to critique colonial practices.[19]

The film opens in the midst of a meeting, during which a group of scientists decide to build a rocket and fly to the Moon. The rest of the film depicts them carrying out this plan: building and launching the rocket, the Moon landing and events thereon, and the triumphant return to Earth.

Méliès's own iconic visual wizardry, with the rocket crashing into the Moon's right eye, is followed by the classic shift in perspective that has been part of the vocabulary of such voyages since Lucian's *Icaromenippus*: the explorers gaze back upon the Earth from their new vantage point on the Moon. The Selenites once more are fantastical hybrid creatures: now a cross between humanoids and crustaceans. Initial contact, as in many instances (recall the Vulture-Riders in Lucian and the giant ant-like Selenites in Wells) results in the explorers being captured and brought to the leader, though in the film the crustaceans' hold is only brief, and the explorers manage to return to their capsule and fall back to Earth bringing with them a crustacean hanging on the back, which, in time-honoured colonial fashion, they display in chains. While the two sides are fighting on the Moon there is something that strikes the reader of Lucian forcibly. Whenever the explorers hit a crustacean, the lunar creature goes up in a puff of smoke. In Lucian's *True Histories*, the Moon people do not die but "dissolve into the air like smoke." It may of course be that in the film dissolving in a puff of smoke—skilfully done by means of a substitution splice—is purely a dramatic magic effect, as Méliès was well-known for his fascination and skill with magic tricks and had deployed smoke effects in other ways previously, but it is not possible to rule out that he, too, had first-hand knowledge of Lucian's widely read story and that this detail in particular caught and pleased his magician's eye.[20]

diminishing influence

The influence of Lucian's imaginary journey is diminishing as the literature of the ancient Greeks slips, with good reason, from the pole position in the Western literary canon, a position it had held since the fifteenth century. It is not that Lucian's account is not still readily available in translation in at least all the major European languages, but more that knowledge of Lucian himself has diminished to the point where intertextual and

cross-media allusions, if they exist, are sure to go unrecognized by all but a very few, and even when they occur they are likely now to have been filtered through one or more intermediary accounts.[21]

Further, imaginary journeys to the Moon now have a different starting point. We know today how to get to the Moon, and we know, too, that the atmosphere and topography will not support human life without significant technological intervention currently beyond our means. But the moonwalk of 1969 did not diminish the Moon as a site for our fantastical imaginings, it just altered things, so that it is no longer a question of imagining how one might get to the Moon and what sort of creatures one might find upon arrival, but rather how one might make the Moon habitable for humans.[22]

But the pull of Méliès's particular imaginary—and indirectly, therefore, Lucian's—still has the power to inspire, with musicians continuing to take up the challenge in the twenty-first century. Most recently, when Conor Mitchell, the artist-in-residence at the Wexford Opera Festival, was asked to compose a piece for the seventy-first iteration of the festival in 2022, the theme of which was "Magic & Music," he chose as his inspiration Méliès's film. His creation, *Les Selenites*, a half-hour chamber opera, is a fantasy as equally compelling as that of Méliès. The story is described thus:

> A young research student is watching a film from the last century. She is joined by three characters, each lost in time. A man and his friend—both acrobats from the Folies Bergère in Paris—are joined by a young actress with dreams of leaving France and going to New York. The characters inhabit the same space, though time is split between the present and 1902.[23]

Scenes from Méliès's film fill a screen behind the characters as they each muse or interact with it in different ways, including visually via their clothing, as the young actress wears a costume resembling the skimpy sailor's suits of those "eroticized and trivialized caricatures of explorers" who send off the rocket in the film (Ezra 2000, 123), while one of the Folies Bergère acrobats (a nod to the fact that Méliès employed Folies Bergère actors to play the Moon dwellers in his film) puts on a crustacean suit as the two of them discuss the film and its meaning.

Regardless, then, of how knowledgeable we are now about the Moon and the impossibility of its harbouring life, the lure of the imagination and conversations with the imaginary voyages of the past prove hard to set aside.

notes

1. For an introduction to Lucian, see Sidwell 2004. For a case for the *True Histories* to qualify as science fiction, see Georgiadou and Larmour 1998, 44–8.

2. Photius, *Bibliotheca*, 166. For an edition, including Greek text and English translation, of Photius's summary and other evidence of this lost novel, see Stephens and Winkler 1995, 101–72. On what we can discern about the lunar voyage within Diogenes's story, see ní Mheallaigh 2020, 212–22.

3. For a translation of the full text, see Gárriga 2021, 32–111.

4. Plutarch, *On the Face of the Moon*, 940E; trans. Gárriga 2021, 95.

5. Though the first photo of Earth from space, taken from sixty-five miles away, dates to 1946; see "On This Day in Space History, the First Photo Is Taken from Space," Space Center Houston, October 24, 2019, https://www.spacecenter.org/first-photo-taken-from-space/#:-:text=On%20Oct.,accepted%20beginning%20of%20outer%20space.

6. For an easily accessible translation of the full text, see Costa 2005, 45–60.

7. See ní Mheallaigh 2020, 174–5 and 261–90, for more on this ancient tradition of *selenoskopia* (literally "view from the Moon").

8. Smith 2009 discusses this aspect of the tale.

9. Robinson 1979, 129–38, discusses its influence on such works as Thomas More's *Utopia*, François Rabelais's *Pantagreul*, Cyrano de Bergerac's *Histoire comique des états et empires de la lune et du soleil*, and Jonathan Swift's *Gulliver's Travels*.

10. Rosen 1967 is still the most recent commentary and English translation. In his introduction (xvii–xxiii) he discusses the complicated gestation of the work.

11. See Rosen 1967, 36, for the translation and further details.

12. Rosen 1967, 33–4, for the translations quoted from the second note. Rosen also (209–11) interestingly traces, through various correspondence, the challenges Kepler had in translating Plutarch's work into Latin. Chen-Morris 2005 and Swinford 2015 explore the Lucianic and Plutarchan connections.

13. See Poole 2009 for a recent edition. Cressy 2006 is good for wider contextualisation.
14. Poole 2009, 113; also Adams 1995, 72-3.
15. See Poole 2009, 19, for this quotation from Burton.
16. He took the translation (and modified it every so slightly) from Tooke's 1820 English edition of Lucian's works.
17. "Selenite" is a direct translation of Lucian's Greek term for Moon dwellers and was so used by Tooke in his 1820 translation.
18. See Christie 2015 for other contemporary influences on Méliès.
19. Sandner 1998 and Crivelli 2023 both investigate the connections between Verne, Wells, and Méliès with an emphasis on their critique of imperialism. See also Lefebvre 2011.
20. Lefebvre 2011, 59, notes two prior films of Méliès in which a similar effect is achieved, but neither are quite the same: in the 1900 film *Nouvelles luttes extravagantes* (known in English as *Fat and Lean Wrestling Match*) one wrestler jumps onto the stomach of another and there is an explosion with smoke, but the body does not disappear, it just breaks apart; in the 1901 film *L'homme à la tête en caoutchouc* (*The Man with the Rubber Head*) a head is inflated with air until it explodes. In all three films substitution splices are used but for different effects and different reasons.
21. It is worth pointing out, however, that Antonius Diogenes (if not his lunar voyage) is one of the ancient Greek sources that recently inspired Doerr's 2021 novel *Cloud Cuckoo Land* (New York: Scribner).
22. See, for example, Pak 2016 for a deep exploration of terraforming in science fiction, as well as his essay for this volume.
23. The description is taken from the 2022 *Wexford Festival Opera Programme*, 120.

bibliography

Adams, J. 1995. "Outer Space and the New World in the Imagination of Eighteenth-Century Europeans." *Eighteenth Century Life* 19 (1): 70-83.

Chen-Morris, Raz. 2005. "Shadows of Instruction: Optics and Classical Authorities in Kepler's *Somnium*." *Journal of the History of Ideas* 66 (2): 223-43.

Christie, Ian. 2011. "First-Footing on the Moon: Méliès's Debt to Verne and Wells, and His Influence in Great Britain." In *Fantastic Voyages of the Cinematic Imagination: George Méliès Trip to the Moon*, edited by M. Solomon, 65-80. New York: State University of New York Press.

Costa, C. D. N., trans. 2005. *Lucian: Selected Dialogues*. Oxford: Oxford University Press.

Cressy, David. 2006. "Early Modern Space Travel and the English Man in the Moon." *American Historical Review* 111 (4): 961-82.

Crivelli, Sabrina Francesca. 2023. "The Spectacle of the Moon Conquest: How Visual Culture Shaped Méliès *Le voyage dans la Lune* and Its Anti-imperialist Satire." *Early Popular Visual Culture* 21 (4): 407-33.

Ezra, Elizabeth. 2000. *George Méliès: The Birth of the Auteur*. Manchester: Manchester University Press.

Gárriga, Luisa Lesage, ed. and trans. 2021. *Plutarch: On the Face which Appears in the Orb of the Moon: Introduction, Edition, English Translation, and Commentary to the Critical Edition*. Leiden, NL: Brill.

Georgiadou, A., and D. Larmour. 1998. *Lucian's Science Fiction Novel* True Histories: *Interpretation and Commentary*. Leiden: Brill.

dust for fear that the landing module would be swallowed up as if in quicksand (e.g., Gold 1962); the terrain was imaged and pored over in a fine-grained detail that would have left Galileo giddy.

While there was still some faint possibility that the Moon sheltered microbial life (the astronauts were quarantined on their return in case they introduced an interplanetary plague), the process was as deadly to the Moon as the fake chemical erosion invented by *The Times-Dispatch*. Firstly, the development of lunar science cemented the idea of the Moon as a static body, unchanged and unchanging. Then the astronauts walked the surface, sending back photos that looked to be taken in black-and-white film, but were actually in colour, so little of it there was. We saw through our own eyes the grey regolith (the broken rock and dust covering the bedrock), the black shadows, and the blackness of the sky, deeper than the void. The starry lunar night seen by the astronauts did not appear in these photos due to exposure times. Having been stripped of life, the Moon now was denied its own beauty.

The astronauts themselves did not necessarily feel this. Neil Armstrong said the Moon had "a stark beauty all its own. It's like much of the high desert of the United States" (Phillips 2014). Astronaut Alan Bean, after his return from the Apollo 12 mission in late 1969, used his painting skills to portray a distinctly lunar palette of muted mauves and yellows. Talking with lunar scientist Phil Metzger, Bean said he did not find the Moon to be a monotone place: it had its own colours and textures (Gorman 2019, 179).

Nonetheless, the perception of the Moon as a long-dead world inimical to life had taken hold in the popular imagination. The idea of the death of a celestial body was based on a contrast to the Earth as "alive," aided by the iconic *Earthrise* photograph taken in 1968, and in contrast to earlier conceptions of the Moon as part of a cosmology where everything in the heavens partook of "life" in some way. Science and the cultural associations of colour had conspired together to suck the life out of the Moon.

what's at stake—lunar mining

None of this would matter if capitalism had not been victorious at the end of the Cold War. In the ideological vacuum left by the cessation of competition for the Moon, a slow creep started.

6 mythologies of outer space

The success of the Apollo 11 mission made the Moon less critical as an ideological weapon in this war, and for over fifty years there were no further plans for human missions. In space gatherings all over the world, people debated "Moon or Mars?," the question being whether the Moon should be bypassed in favour of throwing all resources toward the next human missions to the "red planet."

In the meantime, changes were afoot. In the 2000s, space agencies such as NASA moved to a model of outsourcing technology and missions to private industry. Space billionaires declared that their wealth would be used to support their boyish ambitions of high tech and space travel. From merely capitalist, the overall tenor of the space world became hyper-capitalist, treating the exploitation of space resources as inevitable. The original UN space treaty provisions about sharing the benefits of space exploration with all humanity were reframed as a disincentive for potential investors. The investor, rather than the astronaut, became the new "envoy of all humanity."

In the span of a decade or so, the debate died. It was no longer "Moon or Mars?" It was Moon *and* Mars, with the former viewed as a test bed for technology and governance. It became a sacrificial lamb to protect possible life on Mars. The Moon was dead and on its corpse the space billionaires started planning their conquest of the solar system. If one questioned this premise publicly, the predominantly white, male Musk bros and suburban scions of colonialism became angry. Not just annoyed, *angry*. As if a living Moon was a personal insult, an assault on their masculinity.

permanently shadowed regions

One reason for the change of direction was that recent studies had shown that the Moon did, in fact, have resources that could support life. In 2008, data collected by India's Chandrayaan 1 lunar orbiter provided evidence that deep craters in the permanently shadowed regions (PSRs) at the lunar south pole were full of a substance more precious than diamonds: water ice. Water and oxygen derived from the ice could be consumed by humans, but this was not the real drawing card. It could also be used to make rocket fuel, powering a local lunar economy and enabling the long trip to Mars. However, the discovery of water, usually considered a prerequisite for life, did not change the entrenched perception of death. The water was neutralized in ice, a potential not yet realized.

The reason the water ice survived was because it was shielded from the heat of the Sun by permanent shadows. For two billion years, only starlight and zodiacal light—the light of the Sun reflected through interplanetary dust—reached the surface of the ice lakes in the craters. Let that sink in: shadows two billion years old. On Earth, the polar regions have six months of light alternating with six months of darkness, with periods of twilight at the changing of the seasons. We do not have such permanent shadows, unless it is in the mouths of deep caves where the lack of light is simply darkness.

As intangible as they are, these shadows seem to me to have intrinsic value. They are among the oldest shadows in the solar system. As a landscape type, such permanently shadowed regions are rare. They are known on the dwarf planet Ceres in the asteroid belt, and on Mercury, where it is thought they also harbour water ice and other volatiles.

Just as the Sun never penetrates the shadows, there are also areas of the south pole that are never (or rarely) in darkness. They are called the peaks of eternal light, recalling Dante's symbol of spiritual apotheosis in the *Divine Comedy* (Daigle-Williamson 2015). The lunar night is savage, with temperatures falling to -130 degrees Celsius. The peaks offer refuge from the cold and an uninterrupted source of solar power for the deep ice mines to come.

Numerous missions are now planned to the PSRs. India's Chandrayaan 3 mission landed close to the south pole in 2023, closely following a failed Russian landing attempt. The NASA Artemis 3 mission to send the first woman to the Moon will land somewhere in the south pole PSR (Speck 2022). Orbiters and rovers are going to prepare the way for industrial infrastructure and habitats in the borderlands between light and shadow.

Inside the shadows, lunar ice miners will work in artificial light just as they do underground on Earth. It won't, most likely, be with drills, blasts, and ice picks. Thermal mining is a technique where the ice will be vaporized, the gas collected and then refrozen to allow for transport and processing (Sowers and Dreyer 2019). The business case for extracting profit along with the ice has already been made. The shadows will swim back to fill the voids left when the lights are turned off. But will they be the same? The two-billion-year reign of darkness will have ended.

How do you rehabilitate a shadow?

what we do in the shadows

The PSRs are a unique landscape that illustrate how natural heritage intersects with cultural heritage. Before, they were simply a neutral, if notable, landform. Now that they have been established to have utility for humans, they are being overwritten with economic and scientific values. But that doesn't seem enough, not for me, anyway. The ancientry, coldness, and power of the dark ice craters is not part of this story, and I think it should be.

The quality of shadows on the Moon is very different to those on Earth. Sunlight reflected from the Moon's gently rounded terrain provides some feeble illumination inside the shadow, as does earthshine, which is a secondary source of light in lunar skies. But without direct sunlight and atmospheric refraction, the depths of shadows are pitch-black, and inside them, the temperature drops radically.

The evolution of my thinking about lunar shadows started with NASA's 2011 guidelines on heritage protection on the Moon. The guidelines propose that buffer or exclusion zones be placed around US sites to protect them from the impacts of dust abrasion during future surface activities. The buffer proposed for Apollo 11 was a circle with a radius of fifty metres. I wondered if this would encompass all parts of the site, and this made me realize that the shadows cast by the hardware abandoned there were also part of the "fabric" of the site.

In searching through the archive of Apollo images, I was very struck by those in which the astronauts appear only as shadows in the photograph they or another crew member are taking. They reminded me of a series of paintings by the Italian artist Giorgio de Chirico in the 1910s. These paintings featured empty urban landscapes with colonnades, towers, and statues casting shadows at odd angles (e.g., *L'enigme du jour* [1914]—see Hollier 1994). They are stark and stylized. Art critics say the use of light and colour evokes melancholy, or even despair. Similarly, the Apollo images, with the silent shadow astronauts stalking on elongated legs, seems to amplify the loneliness of landscape.

When the astronauts left, nothing moved on the lunar surface—but the shadows are still a dynamic part of the site. As the lunar day rolls by, the shadows circle around the object that cast them, like sundials. They are both part of the natural environment and cultural objects. They contribute to the aesthetic significance of the site that is created by the distinct lunar surface and light. Lunar rocks are irregular in shape, but the human-made

shadows are clean lines and angles, or lacy anemones filtered through mesh antennas. Some shadows lie on the surface while others, such as those cast by the ridges on the soles of the astronauts' overshoes, are embedded in the regolith. Underneath and around the hardware is an intangible "shadow site."

The shadows have a symbolic resonance on Earth, as they are a beloved tool of lunar conspiracy theorists to argue that the Apollo landings were filmed in a movie studio. Others have explained the complex reasons why we might not be able to rely on terrestrial experience when using off-Earth shadows as a truth-telling tool (Perlmutter and Dahmen 2008; Platoff 2011). These evanescent effects of light are a battleground of ideologies, signs from which the truth can be read.

Compared to the young shadows of human traces, the shadows of the PSRs are unbearably ancient for something that doesn't technically exist. Their value lies in this continuity. They don't care about us: they lie in "Craters of indifference to human time," as the poet and lunar environmentalist Ceridwen Dovey phrases it (in Dovey and Potts 2020). For all this ancientry and power, however, they are still vulnerable to human predation. Two billion years of darkness can be broken in a moment, and surely this moment should not be taken lightly.

In the PSRs, the shadows both create and conceal treasure from the human gaze. They are an active force in trapping and freezing the water: the ice lakes are a result of their interaction with the complex lunar environment. The craters that cast them have names; perhaps we should give the shadows their own names to acknowledge that their intangibility translates into something more substantial, so much so that it has excited the cupidity of the lunar capitalists.

The Dantean symbolism in which degrees of light represent closeness to heaven, with hell in the pit of darkness, seems apt to describe the contrast between the peaks and crater depths. The temperature range from light to dark is from about -50 degrees Celsius, which is Antarctic-level bearable, to -130 degrees Celsius in the pits. The crater ice lakes resemble the lowlands "where the sun is silent" in *The Inferno*, whence Dante escapes to begin his journey upward (canto 1; Longfellow 1904). The first circle of *Paradiso* is the Moon, which Dante observes is "much like a diamond that the sun has struck": the peaks of eternal light. Here, Beatrice offers to Dante "a new form, light so living that it trembles in your sight" (canto 2). Perhaps it is not that the Moon is dead, but that our vocabulary of planetary light and shade has not yet developed enough to do it justice.

wasteland & wilderness

Just as Dante gives us a symbolic vocabulary of light, T. S. Eliot's iconic modernist poem *The Waste Land* (1922) presents a symbolism of water. As Piechucka (2009) argues, aridity and sterility are strongly linked in the poem. It is notable that Eliot makes rock and water categories of mutual exclusion in the wasteland: "Here there is no water only rock / . . . mountains of rock without water." Without water, the wasteland is inimical to life: "Dead mountain mouth of carious teeth that cannot spit." However, such a perceived lack of resources is sometimes what protects a landscape against the depredations of human exploitation.

On Earth, places seemingly untouched by human hands, like the icefields of the Antarctic or the Namib Desert, are given value. Such landscapes are designated wildernesses worthy of the benevolent protection of wealthy nations, who hold the power to preserve or destroy them. They are also often ideological battlefields, where Indigenous rights come up against the capitalist interests of mining companies; and environmentalists seek to evict the people whose long agency had shaped the landscape declared "pristine" (Fletcher et al. 2021; Pickerill 2008). The wilderness stands in opposition to urban, industrial, and agricultural landscapes.

The Moon's death has deprived it of the opportunity to be perceived as a wilderness in the eyes of many. By this standard, there is nothing there to preserve or maintain. However, it does have the potential to become a wasteland. The Wikipedia article on lunar resources states that the goal of sustainable development on the Moon is to "ensure that future generations are not faced with a barren lunar wasteland by wanton practices."[3]

Human activity transforms landscapes into "wastelands" when resources have been depleted and ecosystems destroyed. As the residue of industrial processes, the wasteland has no further potential to be exploited or "improved." Its natural values have been extinguished, leaving only scars and industrial detritus. The wasteland is vividly evoked in J. R. R. Tolkien's (1955) description of the destruction wrought by warfare on the plain of Dagorlad, a grey landscape of smoking dust cones, poisonous oil sumps, and noxious airs where nothing can live.

These oppositions are firmly grounded in a subset of economic and environmental beliefs held in contemporary Western capitalist societies. They are not universal among the humans for whom the Moon is supposedly a province or common heritage, as stated

in the UN outer space treaties (see this volume's appendix). As Chang (1992, 852) has expressed it, "The core of the Western environmental movement is derived from the present stage of the wasteland. It is not a movement derived from the different world views of indigenous [*sic*] persons, such as Native Hawaiians, who hold completely different attitudes towards scarcity and human influence on nature."

Space industry has a deep entanglement with wastelands. Early launch sites were located in places seen as unproductive and with low populations, such as the forests of French Guiana or the deserts of Woomera in South Australia and White Sands in the United States. This was very much not how these lands were perceived by their traditional owners. Kokatha people knew how to find water in the desert by observing vegetation and soil patterns, while the rocket range required the building of an expensive pipeline to supply the engineers and their families (Gorman 2005).

The Moon doesn't quite fit into either category. It is not wilderness, but it is not yet wasteland—this is a state that may lie in its future, a planet laid waste and abandoned when it no longer serves a purpose as a launch site for Mars, or as a source of minerals valued or scarce on Earth. The mission of lunar sustainability advocates is to postpone this moment for as long as possible. This is not the epitome of ethical and sustainable behaviour it might seem. If the Moon is already dead, how can it die further?

why the moon lives

To finish, I want to present some arguments about why the Moon should not be perceived as dead. An aspect of this is that, unlike the rapid erosion of the lunar surface presented in "The Man in the Moon Is Dying!," some change happens at a pace far slower than our short and frenetic human lives. We judge the Moon by standards it cannot meet, without plate tectonics, vulcanism, and atmosphere. This does not seem like environmental justice to me.

The Moon is currently in the Copernican or Neolunarisian geological age (Guo et al. 2014), which began roughly around eight hundred million years ago and is characterized by craters with bright rays, such as Tycho. In earlier periods the Moon had much more active vulcanism. In this latest phase, the lunar surface is shaped by external forces such as impacts with cosmic rays, micrometeorites, and meteorites. Already human activity is making its own contributions with the impacts of rocket bodies.

This process, which is common on the airless bodies of the solar system, is known as impact gardening. The surface is continually reworked, and ejecta from the impacts is redistributed to other regions. Despite appearances, the lunar surface is in a state of constant renewal. Impact gardening also plays a role in the formation and trapping of water on bodies like the Moon, Ceres, and Mercury (Costello et al. 2020).

Unlike Eliot's wasteland, the Moon has water cycles. Outside the magnificent structures of the polar ice lakes, there is a small-scale and daily creation and dissolution of water molecules in the minute craters caused by micrometeorite bombardment. We hardly know anything about this yet; but it clearly forms part of a larger water ecosystem that, apart from its benefits for human use, is part of a dynamic abiotic ecology (Honniball et al. 2021; Jones et al. 2018; Reiss et al. 2021).

On the surface, particles and rays interact directly with the regolith. Cosmic rays create the helium-3 that so interests humans as a potential power source; micrometeorites strike and melt the dust into shards of obsidian. The dust becomes electrostatically charged and sticky from this bombardment; for the Apollo astronauts it was a nuisance and health hazard, capable of causing equipment failure, lung injury, and seal erosion (Zakharov, Zelenyi, and Popel 2020). But let's reconfigure it from a nuisance to a planetary-scale ecology, responding actively to disturbance by flowing and sticking to moving bodies, even using them for transport off-planet. Inanimate, perhaps; but not without agency as it elicits a reaction from those in contact with it.

The dust has its own unearthly taxonomies. Hidden underneath the surface are microscopic towers and buttresses dubbed fairy castles, created by the static electricity that attracts and repels dust particles with equal measure (Hapke 1967; Szabo et al. 2022). Every bootfall of an Apollo astronaut crushed these sublunarian aerial formations. The fairy castle structure affects how light is reflected from the surface.

I've already spoken of the shadows, but lunar light is equally dynamic. Since the sixteenth century, Earth-based observers have seen what are known as transient lunar phenomena (TLP): "Glows, hazes, mists, brief colour changes and temporary obscurations of lunar surface features" (Hughes 1980, 438). There does not seem to be a single consistent explanation for all TLP characteristics, although outgassing in crater regions certainly accounts for a large proportion of them (Crotts 2009). Discussing the TLP, Hughes (1980, 438) says, "Three thousand million years is a long time for the Moon to be quiet and cold, but is it completely dead? Probably not, is the most reasonable answer."

Colour, then, is less uncommon on the Moon than we might think; but our insistence on correlating colour and life may be at least partially a result of prioritizing human senses such as vision, evolved for terrestrial circumstances. Maybe our eyes don't suit the Moon. Other Earth animals, with fewer cones for colour perception and more rods for light perception, live in a visual world that is no less rich than ours. On the other hand, human eyes are not even the pinnacle of colour perception. The mantis shrimp is known for having the most complex eyes and sophisticated vision in the world of the eyed, with sixteen photoreceptors as opposed to the human three, and the ability to see polarized and ultraviolet light (Cronin et al. 2022). We can only guess at the shades that different eyes might distinguish in the shadowed realms of the lunar surface. And we haven't even started on the acoustic landscape.

The Moon seems dead because we haven't learned to see it as alive. But we are surrounded by decay and death on Earth, and on the Moon we would be the ones bringing death, already introduced with the dead plants on China's Chang'e 4 lander. Imagine if the dominant paradigm of lunar engagement were not a hyper-capitalist, post-Enlightenment dead cosmos with military men writing the script. Along with developing "other forms of knowledge, helped along by a subtle shift in descriptive language," Dovey (2021) urges that we should develop an ethics of kinship rather than of possession.

We would see similarity, not difference, and develop a palette of grey that we would read intimately as we do now the terrestrial landscape, each nuance, each shadow giving meaning. We could navigate by the shadows and travel with the terminator, the dividing line between day and night; and at night, stand with our sister Moon to see the stars with a clarity that only comes by facing the void full on: unafraid and joyful.

notes

1. "The Great Moon Hoax of 1835," *Museum of Hoaxes*, accessed July 20, 2024, https://hoaxes.org/text/display/the_great_moon_hoax_of_1835_text/P5.

2. "The Man in the Moon Is Dying!," *Strange Ago*, July 6, 2017, https://strangeago.com/2017/07/06/man-moon-dying/.

3. Wikipedia, s.v. "Lunar Resources," last modified June 3, 2024, 08:10, https://en.wikipedia.org/wiki/Lunar_resources.

bibliography

Chang, Williamson B. C. 1992. "The 'Wasteland' in the Western Exploitation of 'Race' and the Environment." *University of Colorado Law Review* 63: 849–70.

Costello, E. S., R. R. Ghent, M. Hirabayashi, and P. G. Lucey. 2020. "Impact Gardening as a Constraint on the Age, Source, and Evolution of Ice on Mercury and the Moon." *Journal of Geophysical Research: Planets* 125 (3): e2019JE006172.

Cronin, T. W., M. L. Porter, M. J. Bok, R. L. Caldwell, and J. Marshall. 2022. "Colour Vision in Stomatopod Crustaceans." *Philosophical Transactions of the Royal Society B Biological Sciences* 377 (1862): 20210278.

Crotts, Arlin P. S. 2009. "Transient Lunar Phenomena: Regularity and Reality." *Astrophysical Journal* 697 (1): 1–15.

Daigle-Williamson, Marsha, 2015 *Reflecting the Eternal: Dante's Divine Comedy in the Novels of C. S. Lewis*. Peabody, MA: Hendrickson Publishers.

Dovey, Ceridwen. 2021. "Making Kin with the Cosmos." *Center for Humans and Nature*, April 11, 2021. https://humansandnature.org/making-kin-with-the-cosmos/.

Dovey, Ceridwen, and Rowena Potts. 2020. *Moonrise*. Video. http://www.moonrisefilm.com/.

Fletcher, M. S., R. Hamilton, W. Dressler, and L. Palmer. 2021. "Indigenous Knowledge and the Shackles of Wilderness." *Proceedings of the National Academy of Sciences* 118 (40): 2022218118.

Galilei, Galileo. 1610. *Sidereus Nuncius*. Venice: Thomas Baglioni.

Gee, E. 2020. *Mapping the Afterlife: From Homer to Dante*. Oxford: Oxford University Press.

Gold, T. 1962. "Processes on the Lunar Surface." *The Moon* 14: 433–40.

Gorman, A. C. 2005. "The Cultural Landscape of Interplanetary Space." *Journal of Social Archaeology* 5 (1): 85–107.

———. 2015. "Let the People Decide New Place Names on Mercury and Pluto." *The Conversation*, April 20, 2015. https://theconversation.com/let-the-people-decide-new-place-names-on-mercury-and-pluto-40079.

———. 2019. *Dr Space Junk vs the Universe: Archaeology and the Future*. Sydney: NewSouth Books.

Guo, Dijun, Jianzhong Liu, Li Zhang, Jinzhu Ji, Jingwen Liu, and Liang Wang. 2014. "The Methods on Lunar Geochronology Study and the Subdivisions of Lunar Geologic History." *Earth Science Frontiers* 21 (6): 45–61.

Hapke, B. 1967. *Photometric and Other Laboratory Studies Relating to the Lunar Surface*. NASA contractor report, NASA-CR-89078. https://ntrs.nasa.gov/citations/19670028868.

Hollier, Denis. 1994. "Surrealist Precipitates: Shadows Don't Cast Shadows." Translated by Rosalind Krauss. *October* 69: 110–32.

Honniball, C. I., P. G. Lucey, S. Li, S. Shenoy, T. M. Orlando, C. A. Hibbitts, D. M. Hurley, and W. M. Farrell. 2021. "Molecular Water Detected on the Sunlit Moon by SOFIA." *Nature Astronomy* 5 (2): 121–7.

Hughes, David W. 1980. "Transient Lunar Phenomena." *Nature* 285 (5765): 438.

Jones, B. M., A. Aleksandrov, K. Hibbitts, M. D. Dyar, and T. M. Orlando. 2018. "Solar Wind–Induced Water Cycle on the Moon." *Geophysical Research Letters* 45 (20): 10,959–67.

Kalachanis, K., E. Theodosius, and M. S. Dimitrijević. 2018. "Anaxagoras and His Contributions to Astronomy." *Astronomical and Astrophysical Transactions* 30 (4): 523–30.

Lewis, C. S. (1938) 1968. *Out of the Silent Planet*. London: Pan Books.

Longfellow, Henry Wadsworth. 1904. *The Divine Comedy* [translation]. Boston: Houghton Mifflin.

Nilsson, M. P. 1940. "The Origin of Belief among the Greeks in the Divinity of the Heavenly Bodies." *Harvard Theological Review* 33 (1): 1–8.

Perlmutter, D. D., and N. S. Dahmen. 2008. "(In)visible evidence: Pictorially Enhanced Disbelief in the Apollo Moon Landings." *Visual Communication* 7 (2): 229–51.

Phillips, T. 2014. "Wide Awake on the Sea of Tranquillity." NASA, July 9, 2014. https://www.nasa.gov/missions/apollo/apollo-11/wide-awake-on-the-sea-of-tranquillity/.

Pickerill, Jenny. 2008. "From Wilderness to WildCountry: The Power of Language in Environmental Campaigns in Australia." *Environmental Politics* 17 (1): 95–104.

Piechucka, Alicja. 2009. "'The River Is Within Us, the Sea Is All About Us': Symbolist-Inspired Water Motifs in T. S. Eliot's Verse." *Acta Universitatis Lodziensis. Folia Literaria Anglia* 8: 43–58.

Platoff, Anne M. 2011. "Six Flags Over Luna: The Role of Flags in Moon Landing Conspiracy Theories." Paper presented at the 24th International Congress of Vexillology, Washington, DC, August 1–5, 2011. https://escholarship.org/content/qt5h31r40r/qt5h31r40r.pdf.

Reiss, P., T. Warren, E. Sefton-Nash, and R. Trautner. 2021. "Dynamics of Subsurface Migration of Water on the Moon." *Journal of Geophysical Research: Planets* 126 (5): e2020JE006742.

Russell, W. M. S. 1983. "Life and Afterlife on Other Worlds." *Foundation* 28: 34–56.

Sowers, George F., and Christopher B. Dreyer. 2019. "Ice Mining in Lunar Permanently Shadowed Regions." *New Space* 7 (4): 235–44.

Speck, Emilee. 2022. "NASA Astronauts Will Land in Shadowed Regions on the Moon's South Pole." *Fox Weather*, August 19, 2022. https://www.foxweather.com/earth-space/lunar-home-base-nasa-astronauts-will-land-in-one-of-these-regions-on-the-moon.

Szabo, P. S., A. R. Poppe, H. Biber, A. Mutzke, J. Pichler, N. Jäggi, A. Galli, P. Wurz, and F. Aumayr. 2022. "Deducing Lunar Regolith Porosity from Energetic Neutral Atom Emission." *Geophysical Research Letters* 49 (21): e2022GL101232.

Tolkien, J. R. R. 1955. *The Return of the King*. London: George Allen and Unwin.

Zakharov, A. V., L. M. Zelenyi, and S. I. Popel. 2020. "Lunar Dust: Properties and Potential Hazards." *Solar System Research* 54 (6): 455–76.

noreen humble

voyages to the moon:
lucian & his legacy

In her contribution to this volume, Alice Gorman, with stark clarity, outlines the widespread perception of the Moon as dead, a near wasteland ripe for capitalistic exploitation. While this image does not solely belong to the period following the lunar landing of 1969, it was certainly reinforced by that event within the parameters of the colonialist mindset of the dominant players in the space race.

Just as from our earthly perspective we appear unable to grasp the time scale of natural forces at play on our Moon and how our presence, in exploitative form or not, alters these, so, too, from our anthropocentric viewpoint, have we forgotten that for much of the past, and still for many non-Western non-colonial cultures in the present, the Moon, and indeed the other planets, are living entities, often deities. In the ancient Greek tradition, which is effectively behind all Western narratives and mythologizing, the Moon is a goddess, Selene, and part of her mythology is that she falls in love with a mortal but endlessly sleeping youth, Endymion, who in some versions of the myth is the discoverer of the course of the Moon, and in others becomes the king of the Moon.

But while our imagination fails us in these ways, at no time has any amount of hard science, whether attained through the naked eye, increasingly powerful telescopes, satellite imagery, or moonwalks, constrained imaginary speculation about journeying to the Moon or colonizing it. Though imaginary voyages are by no means centred on the Moon alone, the Moon is the closest planetary body, and it is to the Moon that the first imaginary space journeys in the Western tradition go. The earliest of these journeys are found in two works of the ancient Greek author Lucian of Samosata (ca. 125–180 CE): *Icaromenippus* and *True Histories*. These works are striking not least for their imaginative power, their engagement with contemporary scientific knowledge, and their satirical force, but also for the depth and longevity of their influence on virtually all imaginary lunar voyages until at least the early twentieth century. Their reception history is rich and complex so what follows are just a few representative highlights of the long influence of these early imaginings.

ancient greece: setting the scene

Lucian's *Icaromenippus* and *True Histories* date to the second half of the second century CE.[1] They do not appear in a vacuum. Two Greek works that predate them were undoubtedly important sources. The first is a novel by Antonius Diogenes entitled *The Incredible Things beyond Thule*. Though it is now lost, we have a summary of it preserved in a ninth-century encyclopedic work, the *Bibliotheca* of Photius (ca. 810–893), and so know that embedded in it was an imaginary trip to the Moon.[2] The second is the still extant dialogue *On the Face of the Moon* by the ancient Greek biographer and philosopher Plutarch (a work composed likely in the early second century CE).[3] There is no imagined voyage to the Moon in Plutarch's work, but in the course of the lengthy dialogue all contemporary scientific knowledge (astronomical, cosmological, geographical, and catoptrical) about the Moon is discussed. The topics range across the nature of its topography (e.g., it is argued that it is full of mountains and valleys), its substance, velocity, phases, eclipses, etc., filtered through a variety of different philosophical outlooks as represented by the different interlocutors. The dialogue ends with a lengthy myth explaining that the purpose of the Moon is as a halfway house during the life cycle of souls. Part of the discussion also turns to speculation about whether or not the Moon is inhabited, during which expression is given to the hypothesis that if there are inhabitants, from their point of view, "they would be much more astonished that the Earth—looking at it as the dregs and dirt of the cosmos, glimpsing through moisture, steam and clouds as an unlit, low and immobile place—might generate and nourish living beings that take part in motion, breathing and warmth."[4]

Since 1969 it is no longer possible for us to un-know what it is like to see the Earth from the Moon,[5] but this conjuring of the lunar perspective of Earth has been a feature of speculations about and imaginary voyages to the Moon from the start, and Plutarch no less than Lucian remains an important touchstone for all the works discussed below.

Lucian's two lunar voyages are different in every possible way. The shorter of the two, the *Icaromenippus*, is a dialogue between one Menippus and an anonymous friend.[6] It, like many of Lucian's works, is a satire, here poking fun at philosophers and the wild excesses of scientific speculation of the day concerning the Moon. Tired with the trivialities of life on Earth, Menippus assembles a pair of wings from an eagle and a vulture so that he can find the answer to such questions as what the Sun was, why the Moon changed shape, etc. Upon reaching the Moon he turns his gaze upon the Earth, but it is so small that he despairs about being able to see it properly, until the philosopher Empedocles appears (all burned up, having thrown himself into Mount Aetna) and reveals to him that if he flaps his eagle's wing he will soon find he has the sight of an eagle. He is then able to see human hypocrisy in all its forms, relating all manner of behaviours, mostly unsavoury, and noting how overwhelming it is to take in the spectacle of the world all at once. This lengthy reflection on what is happening on Earth recalls but greatly expands upon Plutarch's brief lunar perspective on our world.[7] As Menippus is about to leave to fly farther to the realm of Zeus, the Moon speaks to him about the slanderous ways the philosophers talk about her, and asks him to get Zeus to do something about this. Menippus flies off, then, to the realm of Zeus, reports his and the Moon's complaints, and the assembly of gods agree to annihilate all the philosophers—*after* the festival season, so that they get the benefit of all the sacrificial offerings first.

While in the *Icaromenippus* the focus is on viewing the Earth from the Moon, the opposite is the case in the *True Histories*, where a much more elaborate journey to a richly inhabited Moon is imagined as part of a series of fantastical adventures that the protagonists undergo (for a complete translation of the journey, see Keith Sidwell's contribution to this volume). This, too, is a deeply satirical work. Travel narratives are certainly the main focus of the satire, but few poets, historians, philosophers, and scientists are exempt from attack. The broader narrative begins with the narrator and fifty companions setting off on a sea journey toward the Pillars of Hercules (the promontories that flank the entrance to the Strait of Gibraltar). Blown off course, they begin their fantastical journey. They first encounter rivers of wine, and when investigating the source come across the first of a number of hybrid creatures: vine-women. Those of the companions who succumbed to their charms were held fast by their genitals and grafted to them,

becoming, likewise, grape-bearing vine-creatures. Departing from this place they are swept up by a whirlwind and soon they find themselves on the Moon, where they are at first captured by gigantic Vulture-Riders and brought to Endymion, the king of the Moon (the feminine Moon has no voice in this work; in fact the feminine is eschewed completely here, even for reproductive purposes). They are not treated badly and discover that Endymion is at war with Phaethon, the king of the Sun, over who gets to colonize the Morning Star—a critique of colonization thus finding a place already in this earliest of imaginary voyages.[8] The war is related. Phaethon is the victor and his postwar building of a cloud wall in the air causes an eclipse, until it is removed and peace established by a treaty. Not only do the armies of the two sides consist of monstrous hybrid creatures, but the inhabitants of the Moon are fantastical creatures who defy gender and sexual norms: the lunar inhabitants are all men, who gestate their children in their calves, and a race of tree-men live side by side with them, also androgynous with wildly imaginative reproductive means. No practices bear any resemblance at all to those on Earth. While the narrative is focused on the strangeness of life on the Moon itself, there is a brief description of how things on Earth can be seen and heard, here via a mirror positioned over a well. Though Endymion entreats the travellers to stay, laden with gifts they set out on their way again in their ship, finally setting down in the sea again after four days, where they are swallowed by a whale. Their fantastical adventures continue from there, the voyage to the Moon being only one portion of the whole work.

Together Lucian's journeys set the parameters for later imaginary voyages with the key elements being an elaborate framing story starting in the real world, the obligatory imagining of how the Earth looks from the Moon, gigantism, and the hybridity of creatures who live on the Moon. The strong critique of colonialism in the *True Histories* will manifest as a theme again in later journeys, though paradoxically not so much in those written during the wave of colonization in the early modern period.

16th century europe & the scientific revolution

There is a renewed interest in imagining voyages to the Moon in the wake of the Scientific Revolution, particularly after the publication in 1543 of Nicolaus Copernicus's (1473–1543) *De revolutionibus orbium coelestium* (*On the Revolutions of the Heavenly Spheres*). What these voyages might have looked like had the works of Plutarch and Lucian not also been, by this time, widely available in print, not just in Latin but increasingly in the major vernacular languages in Europe, is hard to say. Lucian was popular

both in schools and more generally. His satirical bent appealed greatly, so that a work like the *True Histories* was not just a model for wacky off-world journeying, but also for its mode of attack.[9] The fact that Erasmus's Latin translation of the *Icaromenippus*, first published in 1514, was reprinted fifteen times by the middle of the century played no small role in the dissemination of that work too. But even before the text or its translation was in print, the circulation of manuscripts of both in the fifteenth century ensured their influence was already being felt. The *Icaromenippus*, for example, is undoubtedly in Ludovico Ariosto's (1474–1533) mind when he composes a brief journey to the Moon in his *Orlando Furioso* (34.68–86), first published in 1516 (Mac Carthy 2009).

The most important of Lucian's direct successors in terms of combining science with a fantastical lunar voyage was Johannes Kepler (1571–1630). His *Somnium*, begun in 1593, was published posthumously in 1634.[10] The treatise proper is fairly short but accompanied by copious lengthy notes. Its purpose, Kepler says in the fourth note, "is to use the example of the Moon to build up an argument in favor of the motion of the Earth."[11] It starts by him falling asleep and dreaming of reading a book, composed by a fictional Icelandic astronomer, Duracotus, who relates a portion of his life story, starting with some adventures, which include learning about sidereal matters from the contemporary Danish astronomer Tycho Brahe. Upon his return home, Duracotus's mother tells him she has the ability to commune with the daemons of the Moon, here named Levania (based on the Hebrew, *Lebana*, which Kepler says he favoured over the Greek for its more occult flavour). A daemon then takes over as the narrator and first describes how a human could be carried to the Moon (showing Kepler's theorizing about the effects of gravity on the human body). There follows a description of the physical nature of the Moon, its climate, movements, etc., and how its inhabitants—who are of gigantic size but short-lived—would view the Earth and its movements. The narrative ends abruptly with Kepler awaking from his dream.

The extraordinary meshing of the supernatural framework with scientific knowledge in this work has long been noted. There is no doubt but that the gigantism of Lucian's Moon dwellers is a direct inspiration (Lambert 2002, 11), as is the elaborate set-up in the outer story. Indeed, in the second note on the text Kepler recounts how he chanced upon Lucian's *True Histories*, which he used to help him to learn Greek, and which were his "first steps in the trip to the Moon." He also notes the following: "at Prague, in the year 1604, I quoted extensively from Plutarch in my *Optical Part of Astronomy*." He is referring here to Plutarch's *On the Face of the Moon*, a work he himself translated into Latin.[12]

Kepler's work is not, however, like Lucian's, satirical, nor does it tap into the contemporary anxieties about colonization, and in these points it differs from the rest of the works discussed here. Its purpose is serious, even if the literary and fantastical framework of the lunar voyage owes much to Lucian. Further, the work did not circulate tremendously widely; the first German translation did not appear until 1898 and the first English translation came only in 1965.

The contrast with the translation history of Lucian's works couldn't be starker, or indeed with the translation history of the first English translunar voyage that appeared only four years after Kepler's *Somnium*: Bishop Francis Godwin's (1562–1633) *The Man in the Moone, or a Discourse of a Voyage Thither by Domingo Gonsales the Speedy Messenger* in 1638.[13] Godwin's composition was far less scientific than Kepler's *Somnium*, though it is fully conversant with contemporary scientific theories, but it was also far more successful as a literary work. Between 1638 and 1768 it was published twenty-five times across four languages (Parrett 2004, 50).

There is again an elaborate framing story involving the adventures of one Domingo Gonsales. After some years of exile, while on his way home to Spain, he finds himself on the island of St. Helena, where he discovers a type of wild swan that can carry heavy weights. When his journey resumes, he is attacked and escapes by taking to the air with his wild swans, who simply keep flying higher until he reaches the Moon after twelve days. His first observation is how huge the Earth looks from the Moon compared to the Moon from the Earth, his second how huge the trees are. He discovers a plant of surpassing deliciousness just before he is surrounded by people, first described as twice the height of Earth people, though the longer they live the huger they become. Unlike most other encounters with imaginary Moon inhabitants, this one is peaceful, though the trope of bringing the interloper to their leader is followed.

Godwin's vision of life on the Moon starts out looking like it might be utopian, but that image is soon problematized, not least by the description of another group of inhabitants termed "changelings." They are of ordinary height, thoroughly despised, and serve as slaves to the "genuine" gigantic lunar people. Any child of poor temperament is sent down to Earth in exchange for one of better temperament. This is a peculiar invention by any standard, but it is made all the more astonishing by the way Godwin casually links this practice to contemporary discourse about Indigenous peoples in the "new world":

> And their ordinary vent for them [the children they send away] is a certaine high hill in the North of *America*, whose people I can easily beleeve to be wholly descended of them, partly in regard of their colour, partly also in regard of the continuall use of Tobacco which the *Lunars* use exceedingly much, as living in a place abounding wonderfully with moisture, as also for the pleasure they take in it.

Here Godwin effectively doubly dehumanizes the Indigenous peoples of North America: not only are they inferior, they are not even human but defective, slavish lunar beings.[14]

Gonsales is eventually prompted to depart by constant recall of his family back in Spain and by the fact that his swans, his only means of transportation, start to die. He leaves, with gifts of magical stones, and lands in China nine days later, where some further adventures await him (just as Lucian had left the Moon with gifts from Endymion and embarked on further adventures).

Godwin was highly educated, and as has been well shown, his work draws on many different contemporary sources. In one of these, Richard Burton's *Anatomy of Melancholy* (first published in 1621), is the exhortation "with a *Galelies* glasse, or *Icaromenippus* wings in *Lucian*, command the Spheares and Heavens, & see what is done amongst them."[15] Godwin does the latter both literally—Menippus uses the wing of an eagle and the wing of a vulture to ascend to the moon, Gonsales uses wild swans, one of whose feet has talons like an eagle—and figuratively, with the elaborate framing story that starts in reality and slowly becomes more fantastical and with his continuing to people the Moon with gigantic creatures and plants. Godwin, like Burton, had read his Lucian.

19th & 20th century colonial perspectives from france & england

The next notable Moon voyages I want to look at that have links to Lucian belong to the late nineteenth and early twentieth centuries. Lucian was still readily available in print in all major vernacular languages and was a staple on school curricula throughout Europe and its colonies, and all the literary creators in this section were educated in Latin, and the first also in Greek.

In the mid-nineteenth century the bestselling French novelist Jules Verne (1828–1905) published *De la terre à la lune* (1865), followed five years later by its sequel, *Autour de la lune* (1870). Mankind does not actually land on the Moon in these works and their de-

tail focuses on contemporary technological capacity, specifically with regard to rocketry, so there is not so obvious a link to the Lucianic works here other than in the general sense that they both concern a fantastic voyage to the Moon and are satirical, critiquing both capitalism and colonialism. There are two reasons, though, for mentioning them: first, they were wildly popular and certainly influenced the two slightly later journeys I am going to discuss; secondly, they are sprinkled with references to the past—not to Lucian, but certainly to Plutarch, among other classical writers. For example, when one of the characters is asked whether he thought the Moon inhabited, he answers, "men of great intelligence, such as Plutarch, Swedenborg, Bernardin de St Pierre, and others have, if I mistake not, pronounced in the affirmative" (Verne [1874] 2019, 95). Verne, like his predecessors, acknowledges the tradition he considers himself to be writing within.

Nearly half a century later, in 1901, came the publication of *The First Men in the Moon* by H. G. Wells (1866–1946). Wells, like Verne, satirizes the colonial impulses of his day, but he does so in a far more allegorical and fantastical way. That fact alone puts him more firmly in Lucian's camp, but he also acknowledges the debt openly in two places. When later writing about the literary predecessors for what he termed his "scientific romances," he lists Lucian's *True Histories* (Wells 1933, vii), and, tellingly, the opening epigraph to his *The First Men in the Moon* is a quotation from the opening of Lucian's *Icaromenippus*.[16]

As is customary, Wells creates an elaborate outer story, which in this case leads a Mr. Bedford, an unscrupulous businessman, into the company of an earnest scientist, Professor Cavor, working on a substance, cavorite, that reflects gravity (in one of their early conversations Bedford mentions Verne's *A Trip to the Moon*; see Wells [1901] 2005, 28). Once this is perfected, they successfully voyage to the Moon. They find the environment harsh and challenging upon first stepping out of their capsule, but when day appears plants start growing at an extraordinary rate. That these plants turn out to be intoxicating is a nod to Godwin, as is the fact that the protagonists discover they can leap huge distances with little effort. They soon learn they are not alone: monstrous animals called mooncalves are being herded around by giant, five-feet-tall, ant-like creatures called Selenites.[17] Upon gorging themselves on the plants the voyagers fall into a drugged state, and the next thing they know they are underground, the captives of the Selenites. Bedford urges fighting, Cavor urges restraint. Bedford has his way and they eventually make it back to the surface, having ascertained that the mooncalves mine gold for the ant creatures. In the end Bedford gets back to the capsule and makes his way back to Earth with some of the gold, intent on making a profit out of all this, which, happily, he fails to do.

The last example of imaginary lunar voyaging showing direct Lucianic influence is the 1902 film *Le Voyage dans la lune* by Georges Méliès (1861–1938). While the immediate and general inspiration for Méliès's film is agreed to be Verne's and Wells's novels,[18] there are strong Lucianic elements to be found too. And like all his models, Méliès's uses his chosen medium to critique colonial practices.[19]

The film opens in the midst of a meeting, during which a group of scientists decide to build a rocket and fly to the Moon. The rest of the film depicts them carrying out this plan: building and launching the rocket, the Moon landing and events thereon, and the triumphant return to Earth.

Méliès's own iconic visual wizardry, with the rocket crashing into the Moon's right eye, is followed by the classic shift in perspective that has been part of the vocabulary of such voyages since Lucian's *Icaromenippus*: the explorers gaze back upon the Earth from their new vantage point on the Moon. The Selenites once more are fantastical hybrid creatures: now a cross between humanoids and crustaceans. Initial contact, as in many instances (recall the Vulture-Riders in Lucian and the giant ant-like Selenites in Wells) results in the explorers being captured and brought to the leader, though in the film the crustaceans' hold is only brief, and the explorers manage to return to their capsule and fall back to Earth bringing with them a crustacean hanging on the back, which, in time-honoured colonial fashion, they display in chains. While the two sides are fighting on the Moon there is something that strikes the reader of Lucian forcibly. Whenever the explorers hit a crustacean, the lunar creature goes up in a puff of smoke. In Lucian's *True Histories*, the Moon people do not die but "dissolve into the air like smoke." It may of course be that in the film dissolving in a puff of smoke—skilfully done by means of a substitution splice—is purely a dramatic magic effect, as Méliès was well-known for his fascination and skill with magic tricks and had deployed smoke effects in other ways previously, but it is not possible to rule out that he, too, had first-hand knowledge of Lucian's widely read story and that this detail in particular caught and pleased his magician's eye.[20]

diminishing influence

The influence of Lucian's imaginary journey is diminishing as the literature of the ancient Greeks slips, with good reason, from the pole position in the Western literary canon, a position it had held since the fifteenth century. It is not that Lucian's account is not still readily available in translation in at least all the major European languages, but more that knowledge of Lucian himself has diminished to the point where intertextual and

cross-media allusions, if they exist, are sure to go unrecognized by all but a very few, and even when they occur they are likely now to have been filtered through one or more intermediary accounts.[21]

Further, imaginary journeys to the Moon now have a different starting point. We know today how to get to the Moon, and we know, too, that the atmosphere and topography will not support human life without significant technological intervention currently beyond our means. But the moonwalk of 1969 did not diminish the Moon as a site for our fantastical imaginings, it just altered things, so that it is no longer a question of imagining how one might get to the Moon and what sort of creatures one might find upon arrival, but rather how one might make the Moon habitable for humans.[22]

But the pull of Méliès's particular imaginary—and indirectly, therefore, Lucian's—still has the power to inspire, with musicians continuing to take up the challenge in the twenty-first century. Most recently, when Conor Mitchell, the artist-in-residence at the Wexford Opera Festival, was asked to compose a piece for the seventy-first iteration of the festival in 2022, the theme of which was "Magic & Music," he chose as his inspiration Méliès's film. His creation, *Les Selenites*, a half-hour chamber opera, is a fantasy as equally compelling as that of Méliès. The story is described thus:

> A young research student is watching a film from the last century. She is joined by three characters, each lost in time. A man and his friend—both acrobats from the Folies Bergère in Paris—are joined by a young actress with dreams of leaving France and going to New York. The characters inhabit the same space, though time is split between the present and 1902.[23]

Scenes from Méliès's film fill a screen behind the characters as they each muse or interact with it in different ways, including visually via their clothing, as the young actress wears a costume resembling the skimpy sailor's suits of those "eroticized and trivialized caricatures of explorers" who send off the rocket in the film (Ezra 2000, 123), while one of the Folies Bergère acrobats (a nod to the fact that Méliès employed Folies Bergère actors to play the Moon dwellers in his film) puts on a crustacean suit as the two of them discuss the film and its meaning.

Regardless, then, of how knowledgeable we are now about the Moon and the impossibility of its harbouring life, the lure of the imagination and conversations with the imaginary voyages of the past prove hard to set aside.

notes

1. For an introduction to Lucian, see Sidwell 2004. For a case for the *True Histories* to qualify as science fiction, see Georgiadou and Larmour 1998, 44–8.

2. Photius, *Bibliotheca*, 166. For an edition, including Greek text and English translation, of Photius's summary and other evidence of this lost novel, see Stephens and Winkler 1995, 101–72. On what we can discern about the lunar voyage within Diogenes's story, see ní Mheallaigh 2020, 212–22.

3. For a translation of the full text, see Gárriga 2021, 32–111.

4. Plutarch, *On the Face of the Moon*, 940E; trans. Gárriga 2021, 95.

5. Though the first photo of Earth from space, taken from sixty-five miles away, dates to 1946; see "On This Day in Space History, the First Photo Is Taken from Space," Space Center Houston, October 24, 2019, https://www.spacecenter.org/first-photo-taken-from-space/#:~:text=On%20Oct.,accepted%20beginning%20of%20outer%20space.

6. For an easily accessible translation of the full text, see Costa 2005, 45–60.

7. See ní Mheallaigh 2020, 174–5 and 261–90, for more on this ancient tradition of *selenoskopia* (literally "view from the Moon").

8. Smith 2009 discusses this aspect of the tale.

9. Robinson 1979, 129–38, discusses its influence on such works as Thomas More's *Utopia*, François Rabelais's *Pantagreul*, Cyrano de Bergerac's *Histoire comique des états et empires de la lune et du soleil*, and Jonathan Swift's *Gulliver's Travels*.

10. Rosen 1967 is still the most recent commentary and English translation. In his introduction (xvii–xxiii) he discusses the complicated gestation of the work.

11. See Rosen 1967, 36, for the translation and further details.

12. Rosen 1967, 33–4, for the translations quoted from the second note. Rosen also (209–11) interestingly traces, through various correspondence, the challenges Kepler had in translating Plutarch's work into Latin. Chen-Morris 2005 and Swinford 2015 explore the Lucianic and Plutarchan connections.

13. See Poole 2009 for a recent edition. Cressy 2006 is good for wider contextualisation.
14. Poole 2009, 113; also Adams 1995, 72–3.
15. See Poole 2009, 19, for this quotation from Burton.
16. He took the translation (and modified it every so slightly) from Tooke's 1820 English edition of Lucian's works.
17. "Selenite" is a direct translation of Lucian's Greek term for Moon dwellers and was so used by Tooke in his 1820 translation.
18. See Christie 2015 for other contemporary influences on Méliès.
19. Sandner 1998 and Crivelli 2023 both investigate the connections between Verne, Wells, and Méliès with an emphasis on their critique of imperialism. See also Lefebvre 2011.
20. Lefebvre 2011, 59, notes two prior films of Méliès in which a similar effect is achieved, but neither are quite the same: in the 1900 film *Nouvelles luttes extravagantes* (known in English as *Fat and Lean Wrestling Match*) one wrestler jumps onto the stomach of another and there is an explosion with smoke, but the body does not disappear, it just breaks apart; in the 1901 film *L'homme à la tête en caoutchouc* (*The Man with the Rubber Head*) a head is inflated with air until it explodes. In all three films substitution splices are used but for different effects and different reasons.
21. It is worth pointing out, however, that Antonius Diogenes (if not his lunar voyage) is one of the ancient Greek sources that recently inspired Doerr's 2021 novel *Cloud Cuckoo Land* (New York: Scribner).
22. See, for example, Pak 2016 for a deep exploration of terraforming in science fiction, as well as his essay for this volume.
23. The description is taken from the 2022 *Wexford Festival Opera Programme*, 120.

bibliography

Adams, J. 1995. "Outer Space and the New World in the Imagination of Eighteenth-Century Europeans." *Eighteenth Century Life* 19 (1): 70–83.

Chen-Morris, Raz. 2005. "Shadows of Instruction: Optics and Classical Authorities in Kepler's *Somnium*." *Journal of the History of Ideas* 66 (2): 223–43.

Christie, Ian. 2011. "First-Footing on the Moon: Méliès's Debt to Verne and Wells, and His Influence in Great Britain." In *Fantastic Voyages of the Cinematic Imagination: George Méliès Trip to the Moon*, edited by M. Solomon, 65–80. New York: State University of New York Press.

Costa, C. D. N., trans. 2005. *Lucian: Selected Dialogues*. Oxford: Oxford University Press.

Cressy, David. 2006. "Early Modern Space Travel and the English Man in the Moon." *American Historical Review* 111 (4): 961–82.

Crivelli, Sabrina Francesca. 2023. "The Spectacle of the Moon Conquest: How Visual Culture Shaped Méliès *Le voyage dans la Lune* and Its Anti-imperialist Satire." *Early Popular Visual Culture* 21 (4): 407–33.

Ezra, Elizabeth. 2000. *George Méliès: The Birth of the Auteur*. Manchester: Manchester University Press.

Gárriga, Luisa Lesage, ed. and trans. 2021. *Plutarch: On the Face which Appears in the Orb of the Moon: Introduction, Edition, English Translation, and Commentary to the Critical Edition*. Leiden, NL: Brill.

Georgiadou, A., and D. Larmour. 1998. *Lucian's Science Fiction Novel* True Histories: *Interpretation and Commentary*. Leiden: Brill.

Lambert, Ladina Bezzola. 2002. *Imagining the Unimaginable: The Poetics of Early Modern Astronomy*. Amsterdam: Rodopi.

Lefebvre, Thierry. 2011. "A Trip to the Moon: A Composite Film." In *Fantastic Voyages of the Cinematic Imagination: Georges Méliès's Trip to the Moon*, edited by M. Solomon, 49–63. New York: State University of New York Press.

Mac Carthy, Ita. 2009. "Ariosto the Lunar Traveller." *Modern Language Review* 104: 71–82.

ní Mheallaigh, Karen. 2020. *The Moon in the Greek and Roman Imagination: Myth, Literature, Science and Philosophy*. Cambridge: Cambridge University Press.

Pak, C. 2016. *Terraforming. Ecopolitical Transformations and Environmentalism in Science Fiction*. Liverpool: Liverpool University Press.

Parrett, Aaron. 2004. *The Translunar Narrative in the Western Tradition*. Aldershot, UK: Ashgate.

Poole, William, ed. 2009. *The Man in the Moone, Francis Godwin*. Peterborough, ON: Broadview Press.

Robinson, C. 1979. *Lucian*. London: Duckworth.

Rosen, E. 1967. *Kepler's Somnium. The Dream, or Posthumous Work on Lunar Astronomy*. Madison: University of Wisconsin Press.

Sandner, David. 1998. "Shooting for the Moon: Méliès, Verne, Wells, and the Imperial Satire." *Extrapolation* 39 (1): 5–25.

Sidwell, Keith, trans. 2004. *Lucian: Chattering Courtesans and Other Sardonic Sketches*. London: Penguin.

Smith, S. D. 2009. "Lucian's True Story and the Ethics of Empire." In *A Lucian for Our Times*, edited by A. Bartley, 79–91. Cambridge: Cambridge Scholars Publishing.

Stephens, Susan, and John Winkler, eds. 1995. *Ancient Greek Novels: The Fragments*. Princeton, NJ: Princeton University Press.

Swinford, Dean. 2015. "The Lunar Setting of Johannes Kepler's Somnium, Science Fiction's Missing Link." In *Classical Traditions in Science Fiction*, edited by B. M. Rogers and B. E. Stevens, 27–38. Oxford: Oxford University Press.

Tooke, William. 1820. *Lucian of Samosata. From the Greek with Comments and Illustrations of Wieland and Others*. 2 Vols. London: Longman, Hurst, Rees, Orme, and Brown.

Verne, Jules. (1874) 2019. *From the Earth to the Moon, and a Trip Round It*. Orinda, CA: Seawolf Press. Reprint of the 1874 English translation by Louis Mercier and Eleanor E. King.

Wells, H. G. (1901) 2005. *The First Men in the Moon*. Reprint. London: Penguin.

———. 1933. *The Scientific Romances of H. G. Wells*. London: Victor Gollancz.

"Spiders of Mighty Bigness." Illustration by William Strang from *Lucian's True History*, translated by Francis Hickes (London 1894), p. 41.

translation by **keith sidwell**

lucian's voyage to the moon

The following imaginary voyage to the Moon is but one of a series of fantastical voyages described in a work by Lucian of Samosata (ca. 125–180 CE) entitled *True Histories*. The work begins with a prologue in which the author warns his readers that he has written this story—in which he himself is the protagonist—so as not to be left out of the current mania for telling lies and that they should not believe a word he says in it. Moreover, the stories consist of parodies of the writings of poets, historians, and philosophers, which the astute reader will recognize from their knowledge of Greek literature and use as food for intellectual inquiry. It is worth noting that Lucian's parodic play with ancient literary models is very evident in the description below of the war between the Heliots and the Selenites. The catalogue of troops looks back to the "Catalogue of Ships" in Homer, *Iliad* 2, and the general description of the battle deliberately recalls several passages from well-known late fifth- and early fourth-century BCE historical works by the Athenian writers Thucydides and Xenophon. In particular, for those who know their Thucydides, the change of mind of the victorious Heliots over the fate of the Selenites specifically evokes the Mytilenean debate in book 3 of Thucydides's work, and the form of the final treaty resembles that made between the Athenians and Spartans in book 5 of Thucydides.

The narrative itself begins right on the edge of the known world, at the Pillars of Hercules (i.e., the Strait of Gibraltar). Setting sail, after eighty days the ship makes landfall on a remarkable island, where the narrator, Lucian, and his crew encounter vines in female form who seduce some of them (who then remain rooted, as it were, to the spot). Re-embarking at dawn, they sail on, and it is here that their adventure to the Moon begins (*True Histories* 1.9–28).

About midday, when the island was no longer in sight, a whirlwind arose. It twirled the ship around and lifted it into the air about three hundred stades. But it didn't set it back down onto the sea. Instead, as it hung up above in mid-air, a wind struck the sails and carried it along, bellying out their cloth. For seven days and an equal number of nights we ran across the ether. Then on the eighth we spotted a large land, like an island in the sky, bright and spherical and lit up by a great light. We approached it, dropped anchor, and disembarked. On reconnoitering the ground, we found that it was both inhabited and under cultivation. While by day we could see nothing from there, when darkness came on, we could distinguish many other islands nearby, fire-coloured, some larger, some smaller. And there was another land below, with cities on it and rivers, seas, forests, and mountains. We inferred that this was the one inhabited by us.

When we determined to go even farther inland, we were taken prisoner on encountering the Vulture-Riders, as they are called by the inhabitants. The Vulture-Riders are actually men riding on enormous vultures and managing the birds like horses. The reason they can do this is that the vultures are enormous and mostly three-headed. You might be able to understand their size from the following analogy: each of the wings they have is longer than the mast of a large merchant ship. The task entrusted to these Vulture-Riders is to patrol the land by flying around and to bring to the king any strangers they might find. And that is why when they had taken us into custody, they brought us before him. He took one look at us and, guessing from our clothing, said, "So you are Greeks, then, strangers?" When we said we were, he asked, "So how did you get here with so much space to get through?" And we told him the whole story. Then he began to relate to us his own tale. He, too, was a human. His name was Endymion. He had been asleep one time when he was spirited away from our Earth and on arrival had become king of the country. He told us that his land was the one that appeared to us down below as the Moon. Nonetheless, he bade us be of good cheer and not to suspect any danger. We would have to hand everything we needed. He continued, "And if I win the war that I am currently waging against the inhabitants of the Sun, you will have the happiest of

lives among us." We in turn inquired who the enemy were and what was the reason for the dispute. Endymion replied, "Phaethon, the king of the Sun's inhabitants (I need to tell you that that celestial body is also lived on, just like the Moon) has been warring against us for a long time now. The reason it began was as follows. One time I gathered together the neediest of those living under my jurisdiction because I wished to send out a colony to the Morning Star. It was empty and no one lived there. So Phaethon was jealous and stopped the party of settlers by meeting them on Ant-Riders in the middle of their journey. Well, we were defeated then because we were no match for their army and retreated. But as things stand now, I want to start the war again and to send out the colony. If you are willing, join me in my expedition and I will give each one of you vultures of the kingly class and all the rest of the equipment of war. It is tomorrow that we shall be making our sortie." I replied, "Make it so, since you think it a good idea."

For the moment, then, we stayed with him and feasted. But in the morning, we got up and into fighting order. This was because the scouts were telling us that the enemy were close by. Now our army was 100,000 strong, not counting the bearers, the engineers, the infantry, and the foreign allies. Of these 80,000 were Vulture-Riders and 20,000 were mounted on Herb-Wings. The latter is also a huge bird, which is covered all over by shaggy herbs, while its wing feathers are pretty much like lettuce leaves. Next to these the Millet-Slingers and Garlic-Warriors were stationed. He also had allies come to him from the Great Bear, 30,000 Flea-Archers and 50,000 Wind-Runners. Of these the Flea-Archers ride on gigantic fleas—and this is how they get their name. Each of these fleas is the size of twelve elephants. The Wind-Runners are infantry soldiers, but they ride the air without wings. The way they manage this is as follows. They wrap themselves in tunics reaching to their feet, then they let them belly out in the wind like sails and are carried along as though they were ships. For the most part soldiers like these act as peltasts during battles. It was said that 70,000 Sparrow-Acorns and 50,000 Crane-Riders were to arrive from the stars above Cappadocia. But I did not see them, because they never arrived. This is why I have not had the courage to describe their natures, as monstrous and unbelievable things were said about them.

Such was the force under Endymion. They were all equipped the same way: their helmets were made from beans, as they have massive and strong ones there. Their cuirasses all have scales made of lupine, since they make them by sewing together the pods of these plants; the ones they grow there have husks as unbreakable as horn. Their swords and shield, however, are just like the Greek ones. When the moment came, they were arranged in the following order. The Vulture-Riders and the king, with his best warriors around him,

held the right wing, and we were with them. The Herb-Wings took the left wing and the allies the centre in the order they themselves decided upon. The infantry numbered around 60,000,000 and they were arranged thus: they have among them many massive spiders, each one much larger than one of the Cyclades islands. They were ordered to spin a web over the space between the Moon and the Morning Star. They completed this task very quickly and produced a plain on which Endymion marshalled the infantry. Their leader was Nighty, the son of Prince Calm, one of the three commanders.

Turning to our enemies, the Ant-Riders held the right wing and among them was Phaethon. These are enormous beasts, with wings and looking like our own ants—except for their size, for the largest of them was two hundred feet long. It was not just their riders who fought, however. The beasts themselves also did so with their antennae. Their number was said to be somewhere around 50,000. On their right wing the Air-Gnats were stationed, they, too, numbering around 50,000. They were all archers mounted on enormous gnats. Behind them were the Air-Prancers, lightly armed and on foot, but also formidable warriors. They used their slings to fire oversized radishes from a distance. Anyone they hit did not hold out for long but died when a stinking infection set in to their wound. They were said to smear their missiles with mallow poison. Close by them were positioned the Stalk-Mushrooms, hoplites and hand-to-hand fighters, 10,000 in number. They were called Stalk-Mushrooms because they used mushrooms for shields, and for spears the stalks of asparagus plants. Near to them stood the Dog-Acorns, sent to Phaethon by the inhabitants of the Dog-Star, Sirius, 50,000 of them. They are dog-faced men who fight on winged acorns. Phaethon, too, so it was said, had allies who delayed their arrival, namely the slingers he had sent for from the Milky Way and the Cloud-Centaurs. The latter did in fact arrive, when the battle was already decided and there was no need of them anymore. The slingers did not appear at all, however, and for this reason they say that Phaethon became angry with them afterwards and burned their country.

This was the army that Phaethon had when he advanced. The two sides clashed and started fighting after the standards had been raised and the asses had brayed on each side—I must explain that they employ these instead of trumpeters. The left wing of the Heliots fled at once without even coming to grips with the Vulture-Riders, and we pursued them, killing as we went. But their right wing defeated our left and the Air-Gnats sallied and pursued our force as far as the infantry. But when, at this point, they came to help, the enemy turned and fled, especially when they realized that the forces on their left wing had been defeated. The rout was triumphant, and many were taken prisoner, while many also were done to death. The blood ran in great quantity over the

clouds. Consequently, I was led to conjecture that it might have been some such occurrence in ancient times that made Homer suppose that Zeus had rained blood at the death of Sarpedon.

We turned back from our pursuit and set up two trophies, one on the spider's web for the infantry battle, the other on the clouds for the aerial battle. But just as these were being constructed, news was brought by our scouts that the Cloud-Centaurs, who were supposed to have come to Phaethon before the battle, were attacking. And indeed, we could see them approaching, a most paradoxical sight, a combination of winged horses and human beings. The men were the size of the Colossus of Rhodes from halfway up, and the horses as big as a large merchant ship. Still, I have not registered here their number, for fear that it might actually appear unbelievable to anyone, so great was it. Their leader was the archer from the Zodiac. When they realized that their friends had been defeated, they sent a message to Phaethon telling him to attack again and then, assuming battle order, fell upon the Selenites themselves while they were in disorder and scattered because of the pursuit and the search for spoils. They routed them all, chased the king all the way to the city, and slaughtered most of their birds. They also pulled down the trophies, traversed the whole of the plain woven by the spiders, and captured me and two of my companions. Phaethon arrived presently and once more other trophies were being constructed by their side.

We were led off to the Sun the very same day, our hands tied behind us with a hank of spider webbing. They decided, however, not to besiege the city. Instead, they turned back and walled off the middle of the air, with the consequence that the Sun's rays could no longer reach the Moon. The wall was double and made of cloud. Consequently, there was a quite apparent eclipse of the Moon and the whole place was gripped by continual night. Endymion, constrained by these circumstances, sent envoys to beg for the wall to be removed and that they should not stand by and watch them living their lives in darkness. Phaethon's advisers met in assembly twice. The first day they remitted none of their anger. But on the next day they changed their minds, and a peace-treaty was agreed on the following terms.

> The Heliots and their allies have made an agreement as follows with the Selenites and their allies. First, that the Heliots shall destroy the dividing wall and never again attack the Moon and shall return their prisoners of war each for a fixed amount of money. Second, that the Selenites shall allow the rest of the stars at any rate to govern themselves and that they shall not deploy arms against the

Heliots. Third, that each side shall come to the aid of the other, should anyone attack them. Fourth, that every year the king of the Selenites shall pay in tribute to the king of the Heliots 10,000 amphoras of dew and shall hand over 10,000 hostages from their own people. Fifth, that the two sides shall colonize the Morning Star together and that anyone of the other states who wishes may participate. Finally, that the treaty shall be engraved upon a pillar of amber and set up in the middle of the air on the frontier between the two states. Swearing to uphold the agreement were the following: for the Heliots, Fiery, Summery, and Flamey, for the Selenites, Nighty, Monthly, and Bright-Shiny.

Such was the peace treaty that was made. The wall was taken down immediately and they handed us prisoners over. When we arrived back at the Moon, our comrades and Endymion himself came out to meet us and welcomed us with tears. Endymion for his part thought we should stay with him and take part in the colonizing project, promising to give me his own son in marriage (I must explain that there are no women there). I could in no way be persuaded but thought he should send us back down to the sea. When he realized that it was impossible to persuade me, he feasted us for seven days and then sent us on our way.

Now I want to tell you the novel and paradoxical things I noticed while staying on the Moon. First of all, they are not born of woman, but of males. The thing is that they have males as their brides and do not even know the word "woman." Each of them is a bride up to the age of twenty-five, and after that becomes a husband. They do not carry their babies in the womb, but in the calf of the leg. As soon as the leg receives the embryo, it starts to swell. Sometime later, they make an incision and bring the fetus out dead. They then expose it with its mouth open to the wind and bring it to life. I think that this is where the Greeks got the word "womb-calf," because among the Selenites that is what takes the place of the womb for pregnancies. But there is something even more singular I have to relate. Among them there is a race of beings called Dendrites, which is generated in the following manner. They cut off the right testicle of a man and bury it in the Earth. From this there grows a very tall tree, fleshy, like a phallus, but with branches and leaves. The fruit it bears is a crop of acorns, each a cubit in length. When these are ripe, they harvest them and hatch the men. They have prosthetic genitals, however, some of ivory, though the poor make do with wood. These are what they use for sexual intercourse and intimate relations with their spouses. When a man grows old, though, he does not die, but dissipates into air like smoke. All of them are nourished the same way. They light a fire and roast frogs over the embers (I must explain that there

are many of these croaking creatures flying about in the air). As the frogs are roasting, they sit down as though around a table, snaffle the smoke from the vapours, and feast royally. This, then, is the way they eat. But for their drink they use air squeezed into a cup, which sends out a liquid like dew. Nevertheless, they do not urinate or defecate, because they have no orifices as we do. Nor do young boys present their buttocks for intercourse, but the back of the knee above the calf, where they do have an opening.

Among the Selenites anyone who is bald and hairless is considered a beauty. The long-haired they actually loathe. On the comets, however, it is the long-haired who are thought beautiful (I know this because some people who had travelled there told me about them). Moreover, they also grow beards a little above their knees. They have no nails on their toes, either, but are all single-toed. Above their buttocks each one has a long cabbage growing, like a tail. It is always luxuriant and does not get crushed when they fall on their backs. When they blow their noses, the product is a very sharp honey, and whenever they work hard or are exercising, they sweat so much milk from every pore of their bodies, that they can make hard cheeses from it, by dripping in a little bit of the honey. They make an oil from onions that is very rich and as sweet-smelling as myrrh. They have many water-bearing vines. The grapes on the bunches are like hailstones and, in my opinion, whenever the wind gets up and shakes those vines, it is at that point that hail falls on us, as the bunches burst open. They use their stomachs like sporrans, placing in them whatever they need, the reason being that they can be opened and closed again, as they seem not to have any intestines in them. The only thing is that they are hairy and shaggy within, so that when it is freezing their children can hunker down inside.

For clothing the rich wear malleable glass, but the poor woven copper (the reason being that the regions there are rich in this metal, and they work it like wool, softening it with water). About the sort of eyes they have, I am reluctant to speak, in case people think I am lying because the tale is unbelievable, but nonetheless I shall do so. They have eyes that can be removed, so whoever wishes can take them out and keep them safe until he needs to see again. In this way, when he puts them back in, he has his vision back. Many who have lost their own borrow them from others and so are able to see. There are those who keep many spare sets (the rich, naturally). Their ears are plane leaves, except that the men generated from trees are the only ones to have merely wooden ones.

There was yet another wonder that I saw in the king's palace. There is a huge mirror set above a shallow well. If you descend into the well, you can hear everything that is being said by those on our Earth. And if you look up at the mirror, you will see all the cities

and all the nations as though you were standing next to each of them. At that time, I personally saw my relatives and the whole of my native land, but whether they could see me as well, I am no longer able to tell you for sure. If anyone does not believe that things are as I have described them, if he ever gets there himself, he will know that I am telling the truth.

Then we said farewell to the king and his entourage, got on board our vessel, and set sail. Endymion also gave me gifts, two of the glass tunics and five of the copper ones, plus a complete set of the lupine armour. All of these I later left behind in the whale. He also sent with us a thousand Vulture-Riders to accompany us for the first five hundred stades. We passed by many other lands on our voyage, but we did put in at the Morning Star (which was just in the process of being colonized), disembarked, and topped up our water supplies. After re-embarking en route for the Zodiac, we passed by the Sun on our left, grazing the land as we sailed past. We did not disembark, although my comrades very much desired to, because the wind was against it. We were able, however, to look at the land, which was flourishing, rich, well-watered, and full of many good things. When the Cloud-Centaurs saw us, however—they were mercenaries of Phaethon's—they flew up to our ship. But when they learned that we were protected under the treaty, they retreated. The Vulture-Riders had already left by this time.

After a couple more stops in their space journey, Lucian's ship is finally set down on the sea, where he and his crew encounter more paradoxical adventures—being swallowed by a whale, for example, and visiting the Isles of the Blest, where Lucian meets Homer. As a final great lie, after his arrival on "the other continent," the author promises to relate what happened there in a third book—which, of course, he never writes.

For more on Lucian, including a full translation of the *True Histories*, see Keith Sidwell, *Lucian: Chattering Courtesans and Other Sardonic Sketches* (London: Penguin, 2004).

space is part of the land:
reconsidering the relationships between astronomy research, outer space exploration & colonialism

hilding neilson

introduction

Indigenous peoples have lived on the lands that, today, people call North America since time immemorial. It is only one part of the lands inhabited by Indigenous peoples across the world. But Settler cultures, like that of Canada, traditionally refer to land as something inanimate that can be owned, bought, sold, and is a commodity, whereas for many Indigenous peoples land is really Land with a capital L. This is because Land doesn't belong to people but is alive itself. The Land supports people, animals, rocks, plants, etc., and we are part of the Land. The Land cannot be a commodity.

Just as the Land is alive, this perspective includes the air and water as part of the Land. The Land is not only the soil but is the ecosystem around us. In this work, I will show that space and the night sky are also part of that ecosystem and as such we, as a society, need to reconsider how we engage with the night sky and space activities and how our actions are expanding our colonial present and past to these realms in a new colonial future. I will also discuss how in Canada, and globally, the state is violating treaties and Indigenous rights by not consulting First Nations, Inuit, and Métis peoples in how the state will operate in outer space.

However, the first thing to do in this essay is for me to situate myself. I am Mi'kmaq and of Settler heritage from Ktaqmkuk, or the island of Newfoundland. I am a son, a brother, and an uncle. I am an academic astronomer. Being from Newfoundland means living on the lands of the Mi'kmaw and the Beothuk peoples. While the Mi'kmaq continue to live on this land and across northeastern North America, the Beothuk peoples are considered extinct today, some of the first victims of colonial genocide. This work is based on a talk given in the city of Calgary on Treaty 7 lands that are the home of the Blackfoot Confederacy, the Tsúūt'inà First Nation, the Stoney Nakoda, and the Métis peoples.

My perspective as a Mi'kmaw person and an astronomer impacts how I view the night sky. A primary example is the constellation of Ursa Majoris. This is one of the eighty-eight constellations in the night sky codified by the International Astronomical Union in a report in 1930 (Delporte 1930). The constellation has been traced in European writings as far back as Ptolemy (second century CE), in his *Almagest*, and in the earliest views of Western astronomy. However, there are many other stories related to that constellation, such as Muin and the Seven Bird Hunters (e.g., Harris et al. 2017).

The story of Muin and the Seven Bird Hunters is told throughout the year at about the same time in the early morning and starts in the spring when Muin wakes from hiberna-

tion and emerges from her den. Muin is hungry and begins searching for food when she is spotted by Jipjawej or Robin. Jipjawej knows that meat and grease will feed and support his community for some time. Jipjawej picks up his bow and arrow and calls for the other hunters to join the hunt. Chickadee picks up a pot and joins in, followed by Blue Jay, Passenger Pigeon, Gray Jay, Barn Owl, and Saw-Whet Owl. As spring turns into summer, Muin is evading the hunters, but they are keeping up. As fall begins to set in, some of the hunters have fallen away from the hunt. In the night sky those hunters are below the horizon, but Jipjawej and Chickadee and some of the others have kept pace. Muin, however, is tired and frustrated. In response, Muin confronts the hunters, standing on her hind legs growling. Jipjawej sees his chance and fires his arrow, striking Muin in the chest. Blood goes everywhere, covering Jipjawej. Jipjawej flies into the trees and shakes off the blood, staining the leaves red, but a spot on his breast remains stained. Muin passes and Chickadee catches up with the pot ready to cook the meat. The other birds join and begin to celebrate. They gather around the fire dancing and telling stories and sharing the meat and grease throughout the winter as Muin lays on her back in the night sky waiting to re-emerge from her den in the spring.

This story contains significant information about the night sky, include the behaviours of circumpolar stars. These are stars that are above the horizon for the entirety of the year. The story tells us about binary stars: Chickadee is one star, the pot is the companion star. The story is related to the seasons and motions of the stars in the night and throughout the year. The story also highlights the relationships between the land and the sky. The story tells us that bears are only to be hunted in the fall, and not in the spring or summer. The story connects us to the animals of the land, including the extinct passenger pigeon. The story tells us about community and sharing. There are many lessons in this story, as there are in all Indigenous stories and constellations.

What this story illustrates is an understanding of nature and science that, historically, has not been acknowledged. In fact, the story of Muin and the Seven Bird Hunters has been used by anthropologists as evidence that Norse peoples had visited northeastern North America centuries before the British and the French (Speck 1922). That argument erases Indigenous knowledges and methodologies. That erasure continues in our science and astronomy textbooks. Many astronomy textbooks dedicate about one or two pages to Indigenous astronomies, usually comments about Pacific wayfinding or solar observatories for measuring time. The same textbooks will dedicate a whole chapter to Isaac Newton or Galileo. While those scientists made great achievements, such practices illustrate the persistent myth that science was born in Europe.

determine the reference times for time zones across Canada and allowed for measuring spatial coordinates for mapping the land. This was a tool for the colonization of the land.

It was also in the twentieth century that telescopes become larger and were employed more and more for the sake of astronomy. Internationally, large telescopes were built in the United States and Europe. Researchers in Canada wanted to compete and so built telescopes for research. The first two big telescopes in Canada were the Dominion Astrophysical Observatory, built outside of Victoria, BC, in 1918, and the David Dunlap Observatory in Richmond Hill, Ontario, built in 1935.

The David Dunlap Observatory was built thanks to an endowment from the Dunlap family to the University of Toronto that allowed that institution to build what was briefly the largest telescope in the world.[2] The observatory was built on a large tract of land north of the city acquired from a farmer, land that had been taken earlier from the Mississaugas as part of the Toronto Purchase in 1805. The Dunlap family earned their wealth from mining operations in northern Ontario in the traditional lands of the Cree and Anishinaabeg peoples. This telescope was an important part of the research of the University of Toronto in the twentieth century, enabling contributions to the understanding of stellar physics and to the discovery of the first-known black hole, Cygnus X-1, in 1972 by the astronomer Professor Tom Bolton. In the twenty-first century the Dunlap Observatory and associated lands were sold to a real estate company for development, while the observatory buildings were given by the company to the City of Richmond Hill. The profit from the sale was used to develop the Dunlap Institute for Astronomy and Astrophysics at the University of Toronto. This institute continues to fund numerous research projects,[3] and also builds instruments that will be used on telescopes around the world.

For most research in astronomy, however, the traditional sites in Quebec, Ontario, and British Columbia are considered less than ideal for research. This is because of the inadequate number of clear nights, the altitudes of the observatories and potential sites, and the relatively poor atmosphere for viewing due to water in the air. To solve this, Canadian astronomers proposed building a telescope on top of Mauna Kea in Hawaii.[4] This process included joining an agreement with France and Hawaii to build Canada's first four-metre-class facility in 1979. While this was not the first telescope built on the top of Mauna Kea, there has been no clear documentation demonstrating that Canada worked to gain consent from Native Hawaiians; there is only an agreement to use the mountain by sharing the facility with the University of Hawai'i. Since then, Canada has joined the larger Gemini Collaboration of multiple nations sharing ten-meter class tele-

scopes in both Hawaii and Chile. Canada is not the only country to build telescopes in Hawaii and Chile and much discussion has been written previously (de los Reyes 2019).

Most large telescopes in the world today are built on Indigenous land, be it in Chile, Australia, Hawaii, or the southern United States. Swanner (2013) presented an analysis of the development of astronomy on Kitt Peak, southwest of Tucson, Arizona, on Tohono O'odham territory, and how the National Science Foundation and astronomy representatives achieved what they referred to as "consent." Development of the first telescopes on Kitt Peak began in the 1950s, less than a century after the invasion of the area by the US military in the "Indian Wars," and mere decades after the US government redefined the reservation lands. The representatives discussed the telescope with tribal leadership and agreed to pay a modest lease fee of $2,500 per year, even though Kitt Peak is an important part of the identity and culture of the peoples there. It was simply assumed that there was consent for the mountain to be used for astronomy. Since then, legal suits have been brought forward in an effort to revoke the lease, along with protests against further developments, including the building of the VERITAS telescope, which was later relocated.

Today, astronomy and astrophysics are entering the era of Extremely Large Telescopes, a bland phrase for the leap in growth in size of new telescopes and the corresponding increase in their environmental and cultural footprints. This includes plans for (1) the Extremely Large Telescope in Chile, led by the European Southern Observatory, a treaty organization consisting of numerous European nations along with Brazil; (2) the Giant Magellan Telescope, led by the Carnegie Observatory and other astronomy organizations in the United States, with contributions from other nations; and (3) the Thirty Meter Telescope (TMT), led by the University of California and Caltech in partnership with Canada and a handful of other nations. The first two telescopes are being constructed in the Atacama Desert in Chile, while the TMT is planned for construction on Mauna Kea.

The history of building observatories on Mauna Kea has been discussed in detail by Salazar (2014), and Native Hawaiian protest against the observatories and the development of astronomy facilities on the mountain, which has been happening for decades, has reached a climax with the TMT. The TMT observatory, proposed over twenty years ago at the California Extremely Large Telescope, would be among the largest astronomical optical observatories ever built with an estimated cost of US$1 billion (Nelson 2000). The telescope was originally to be sited in Chile, however it was moved to Mauna Kea, where the State of Hawaii had granted a site for the observatory. This led to more legal

challenges by various groups, and protests by Native Hawaiians, who argued that the observatory is not welcome and would be an environmental threat.

The issue came to a head in July 2019. At that time the TMT project had obtained a permit to begin construction of the facility on the mountain. In response, land protectors, comprised of Native Hawaiians and others, set up a peaceful and inspiring blockade on the one road to the summit of Mauna Kea. However, the state chose to respect the telescope first, which led to a number of Native Hawaiian Elders being arrested by Hawaiian police as part of a crackdown (D'Angelo 2019). Those arrests were followed by threats of mass arrests and violence against the remaining land protectors. The land protectors, however, held firm and eventually construction was halted.

During that time, the close relationship between professional astronomy and colonization became crystal clear: as far back as 2015 two senior astronomers sent out an email petition urging their colleagues to support the TMT in which they referred to the protesting Indigenous peoples as "a horde" (Dickerson 2015). Many astronomers and scientists even attempted to frame this as a matter of "science versus religion" and to compare those who were against the TMT as similar to creationists. These were attempts to dismiss Indigenous peoples and their rights as backward and reactionary, and to frame astronomers and telescopes as beneficial and benevolent. Further, the discrimination against the land protectors was not only evident in the United States: at the University of Toronto, emails were broadcast referring to Native Hawaiian protectors as "primitive" and "medieval." It was clear that Canadian astronomers felt they had a right to Mauna Kea ahead of Native Hawaiians.

In 2020, both the Canadian and American Astronomical Societies began the process of writing decadal plans. These are plans for the astronomical community in both countries for the 2020s that set forth priorities for new observatories on Earth and in space along with planning for training of the next generation of professional astronomers and for building a better field. In that process a number of community papers were presented to support Indigenous rights on Mauna Kea, including Neilson and colleagues (2019) and Neilson and Lawler (2019) in Canada, and Kahanamoku and colleagues (2020) in the United States.

At the time of writing, the future of the TMT on Mauna Kea is uncertain. The National Science Foundation in the United States had begun a consultation and environmental impact statement process in Hawaii that will influence its decision of whether to

contribute funding to the project on Mauna Kea.[5] The future of astronomy on Mauna Kea is unclear, but the history of the conflict over the site is a clear example of the continuing relationship between astronomy and colonization today.

light pollution is colonization

The placement of telescopes on Indigenous land has been a form of colonization for more than a century, but it is not the only way in which astronomy and space intersect with colonization. Light pollution is another form of colonization and has been discussed in a number of forums, including by Hamacher, De Napoli, and Mott (2020). Light pollution is colonization because Indigenous peoples, who have lived on these lands in so-called Canada and United States and elsewhere since time immemorial, have a relationship with the land that spans many millennia, and that relationship extends to the night sky.

Stories like that of Muin and the Seven Bird Hunters are common across Indigenous cultures and peoples, and reinforce relationships between people and the night sky, as well as relationships with the land, water, animals, and each other. But this is a story not only of relationships but also one of responsibilities. We hunt the bear in the fall but not in the summer, when Muin is raising cubs; at that time we share food and medicine with community and more. These lessons reflect a set of Indigenous methodologies for understanding the world around us.

There is no one Indigenous methodology. Every nation has its own perspective on its own way of understanding the land and its own way of understanding science, however one wants to define it. But you know there are some commonalities. For instance, one is the idea that nature is familial: we are related to nature; we are not above it. And this is very important. There are many more commonalities and these have been illustrated in the works of Cajete (2000), Lipe and Lipe (2017), and others. For example, Knowledge (with a capital K) is holistic and active, instead of something siloed and taken; and what is above is reflected below. These are just a few concepts noted by Indigenous scholars that can inform a perspective of the night sky and outer space that differs from the traditional Western view.

The story of Muin and the Seven Bird Hunters in Mi'kmaq'i and the Cree story of the Great Bear (Buck 2018), or other Indigenous stories of the handful of stars that overlap with the Big Dipper, are not commonly seen in the popular culture of Canada. When I

teach introductory astronomy courses, the textbooks do not include these stories at all, much less consider them as a way of learning equivalent to Western science. Instead, most, if not all, astronomy textbooks focus on the eighty-eight constellations defined by the International Astronomical Union (IAU) less than a century ago.[6] So instead of Muin, we talk about Ursa Majoris, a bear with a long tail. This constellation is an ancient one tracing its roots to early Greek, Roman, and Mediterranean astronomy. The second-century CE astronomer Ptolemy wrote about the constellation in his *Almagest*, one of the first recorded works of astronomy, and one that has formed the anchor of our understanding of the development of astronomy and physics throughout the centuries. But a bear with a tail is not part of the land in any part of Turtle Island.

Constellations like Ursa Majoris persist because of colonization. The eighty-eight constellations were "defined" by a committee of the IAU that was led by French, Belgian, English, American, and Canadian astronomers, none of whom were Indigenous and only one of whom was a woman. The mandate of the committee was largely to maintain the constellations that were already in the astronomy zeitgeist (Delporte 1930), identified by astronomers such as Ptolemy, Albrecht Dürer (1515), and Friedrich Argelander (1886).[7] As such, the definition of the constellations we learn about from textbooks and popular media is part of the colonial history of astronomy.

While the constellations colonize the sky, we face more modern challenges to our view of the night sky. Today we live in a world of light. The image of the world at night (page 40) was created by NASA scientists for various studies. This first image might not seem too bad, but all of that light detected by satellites is waste: it is light that is not protecting us but bathing us in photons that hide the night sky. The second image (opposite) shows the city of Houston, Texas, at night. In that image, we can trace highways and urban spread. If you are a person in Houston looking up in the night sky you are unlikely to see many stars. When I lived in Toronto, Ontario, on the clearest of nights I could only see a few stars, but I could see many planes. The problem is similar in Calgary, and even in my new home of St. John's, Newfoundland, though it must be said clear nights are rarer here.

This light pollution is colonization. As Hamacher, De Napoli, and Mott (2020) write in "Whitening the Sky: Light Pollution as a Form of Cultural Genocide,"

The city of Houston, Texas, at night (in 2016). Image courtesy of NASA. https://earthobservatory.nasa.gov/images/43196/houston-texas-at-night

notes

1. "The Dominion Observatory," Canada under the Stars, accessed July 25, 2024, http://astro-canada.ca/l_observatoire_federal-the_dominion_observatory-eng.

2. "History," Dunlap Institute for Astronomy and Astrophysics, University of Toronto, accessed July 25, 2024, https://www.dunlap.utoronto.ca/about/history/.

3. The author has received funding for research projects from the Dunlap Institute.

4. "The Canada-France-Hawaii Observatory," Canada under the Stars, accessed July 25, 2024, https://astro-canada.ca/l_observatoire_canada_france_hawai-the_canada_france_hawaii_observatory-eng.

5. "National Science Foundation to Launch EIS Process for Mauna Kea Telescope," *Hawai'i Free Press*, July 19, 2022, http://www.hawaiifreepress.com/Articles-Main/ID/32825/National-Science-Foundation-to-Launch-EIS-Process-for-Mauna-Kea-Telescope.

6. "The Constellations," IAU, accessed July 25, 2024, https://www.iau.org/static/public/constellations/page.html.

7. Funny enough, I had the privilege of working as a post-doctoral researcher at the Argelander Institute for Astronomy at the University of Bonn. Professional astronomy is a small world.

8. "Artemis," NASA, accessed July 25, 2024, https://www.nasa.gov/specials/artemis/.

bibliography

Brodkin, Jon. 2020. "Remote Tribe Says SpaceX Starlink 'Catapulted' Them into 21st Century." *Ars Technica*, October 12, 2020. https://arstechnica.com/information-technology/2020/10/remote-tribe-says-spacex-starlink-catapulted-them-into-21st-century/.

Buck, Wilfred. 2018. *Tipiskawi Kisik: Night Sky Star Stories*. Winnipeg: Manitoba First Nations Education Resource Centre.

Cajete, Gregory. 2000. *Native Science: Natural Laws of Interdependence*. Sante Fe, NM: Clear Light Publishers.

D'Angelo, Chris. 2019. "Native Hawaiians Arrested during Protests over Massive Telescope." *HuffPost*, July 17, 2019. https://www.huffpost.com/entry/hawaii-protests-thirty-meter-telescope-2019_n_5d2f76bee4b020cd993e0a54.

de los Reyes, Mia. 2019. "A Tale of Two Observatories: Astronomy and Indigenous Communities in the Southwest US." *Astrobites*, August 16, 2019. https://astrobites.org/2019/08/16/a-tale-of-two-observatories/.

Delporte, E. 1930. *Délimitation scientifique des constellations (tables et cartes)*. Cambridge: Cambridge University Press.

Dickerson, Kelly. 2015. "This Giant Telescope May Taint Sacred Land. Here's Why We Should Build It Anyway." *Business Insider*, November 18, 2015. https://www.businessinsider.com/30-meter-telescope-should-be-built-mauna-kea-2015-8.

Domingues da Silva, D. B. 2019. *The Atlantic Slave Trade from West Central Africa, 1780-1867*. Cambridge: Cambridge University Press.

Hamacher, Duane W., Krystal De Napoli, and Bon Mott. 2020. "Whitening the Sky: Light Pollution as a Form of Cultural Genocide." *Journal of Dark Sky Studies* 1. arXiv preprint arXiv:2001.11527.

Harris, P., L. Marshall, M. Marshall, and C. Bartlett. 2017. *Muin and the Seven Bird Hunters*. Halifax: Nimbus Publishing.

Kahanamoku, Sara S., Rosanna Alegado, Katie Leimomi Kamelamela, Aurora Kagawa-Viviani, Edward Halealoha Ayau, Davianna Pomaika'i McGregor, Tracy Ku'ulei Higashi Kanahele, et al. 2020. *National Academy of Science Astro2020 Decadal Review: Maunakea Perspectives*. Figshare. https://doi.org/10.6084/m9.figshare.c.4805619.

Kean, Sam. 2019. "Historians Expose Early Scientists' Debt to the Slave Trade." *Science*, April 4, 2019. https://www.science.org/content/article/historians-expose-early-scientists-debt-slave-trade.

Kimmerer, Robin. 2013. *Braiding Sweetgrass: Indigenous Wisdom, Scientific Knowledge and the Teachings of Plants*. Minneapolis, MN: Milkweed Editions.

Lennox, J. 2017. *Homelands and Empires: Indigenous Spaces, Imperial Fictions, and Competition for Territory in Northeastern North America, 1690-1763*. Toronto: University of Toronto Press.

Lipe, K., and D. Lipe. 2017. "Living the Consciousness: Navigating the Academic Pathway for Our Children and Communities." *International Journal of Qualitative Studies in Education* 30 (1): 32-47.

McClellan III, J. E., and F. Regourd. 2000. "The Colonial Machine: French Science and Colonization in the Ancien Régime." *Osiris* 15: 31-50.

Neilson, Hilding. 2019. "Astronomy Must Respect Rights of Indigenous Peoples." *Nature* 572 (7769): 312-13.

Neilson, Hilding, and Elena E. Ćirković. 2021. "Indigenous Rights, Peoples, and Space Exploration: A Response to the Canadian Space Agency (CSA) Consulting Canadians on a Framework for Future Space Exploration Activities." arXiv preprint arXiv:2104.07118.

Neilson, Hilding R., and Samantha Lawler. 2019. "Canadian Astronomy on Maunakea: On Respecting Indigenous Rights." arXiv preprint arXiv:1910.03665.

Neilson, Hilding R., Laurie Rousseau-Nepton, Samantha Lawler, and Kristine Spekkens. 2019. "Indigenizing the Next Decade of Astronomy in Canada." arXiv preprint arXiv:1910.02976.

Nelson, Jerry E. 2000. "Design Concepts for the California Extremely Large Telescope (CELT)." *Proc. SPIE 4004, Telescope Structures, Enclosures, Controls, Assembly/Integration/Validation, and Commissioning*, August 2, 2000, https://doi.org/10.1117/12.393933.

Salazar, J. A. 2014. "Multicultural Settler Colonialism and Indigenous Struggle in Hawai'i: The Politics of Astronomy on Mauna a Wākea." PhD diss., University of Hawai'i.

Speck, Frank G. 1922. *Beothuk and Micmac*. New York: Museum of the American Indian, Heye Foundation.

Swanner, L. A. 2013. "Mountains of Controversy: Narrative and the Making of Contested Landscapes in Postwar American Astronomy." PhD diss., Harvard University.

Weir, Andy. 2014. *The Martian*. New York: Ballantine Books.

fifty years

philip p. langill

at the rothney

Not all universities in Canada fund and operate an astronomical observatory, but those that do typically install (or have installed) such telescopes on their main campuses. That's handy if public outreach is part of the activity, increasing access for the general public, but light pollution restricts what the telescopes can see and do. If a Canadian university hosts an off-campus observatory, it typically has a single telescope with one scientific instrument, probably a CCD (digital) camera plus filters, which satisfies the goal of teaching students how to collect and analyze astronomical data.

There is only one Canadian university that funds and operates a fabulous, advanced astronomical observatory far from its main campus, outside the city's bright lights, with multiple research-grade telescopes and instrument suites, and whose goal is to connect the public with astronomical researchers and scientists in training. This is the mission statement of the University of Calgary's Rothney Astrophysical Observatory (RAO) (see figure opposite).

The RAO was officially christened in January 1973, and it has changed immensely in the decades since. It is challenging to try and describe fifty years of research, teaching, and outreach, as there are so many cool stories to tell and so many awesome people involved. A good way might be to explore some of the more marked contrasts between then and now in three different areas: teaching and technology, public outreach and education, and research.

teaching & technology

In the late 1970s, the RAO was a "one-scope" observatory with two ATCO trailers joined to form the classroom. The sixteen-inch telescope (metric was just gaining traction) was totally manual, with a piggyback finder scope and eyepiece for finding and aligning onto a target star. There was no Internet, but computers were just becoming useful tools for collecting and storing data. Calgary had less than a quarter million people and was a small globe of light on the distant horizon to the northeast.

Imagine a class of about ten undergrads boarding a UCalgary van to leave campus and head out to the RAO to collect data for a class research project to study an interesting variable star. It's winter, so the sun is getting low as students board the van. The Moon and clouds have finally departed and it's looking like a dark and star-filled sky awaits.

Arriving an hour and a bit later, following narrow country roads and a one-lane bridge to cross Fish Creek in Tsuut'ina Nation territory, it's very dark. The students don't notice how cold it is because they are excited to see the telescope and dome and detector and computer, all queued up—it's going to be great! Standing around the perimeter of the dimly lit sixteen-foot-diameter dome, the telescope operator studies a polaroid photograph of a particular field of stars (that they made back on campus a few days before), then looks through the eyepiece. Using buttons on a hand paddle to carefully move the telescope back and forth, and oscillating their head back and forth between the photo and the eyepiece, it takes what seems like forever before they declare that the target star is in the sights of the telescope.

The detector is then fired up and the computer is booted. If all goes well, this whole process takes nearly an hour (if this is the first time a particular star is being hunted through the eyepiece, that could add another half an hour), and by now the students are frozen popsicles feeling a little less excited. And just when the Enter key is about to be pressed for the data acquisition to begin, something weird is noticed on the detector. The technicians and profs scratch their heads for a while, then somebody thinks to look up. Sure enough, the clouds are coming back. Rats! No data is collected, and what's more, that other course's assignment or exam that is looming and should have been worked on tonight didn't get any attention.

You would think this is the perfect way to deter students from doing an astrophysics degree at UCalgary. If these were ordinary students, and if this was an ordinary observatory, it is hard to know how the astrophysics program at UCalgary would have sur-

vived these past fifty years. But there is something magically intangible about that picturesque spot overlooking the foothills of the Rocky Mountains. The Blackfoot people that first lived there must have bestowed onto the land a positive energy that lifts people's eyes to the star-filled sky.

Advance the clock to today, and here's how that same night of data gathering goes, with this same telescope, now christened the Clark-Milone Telescope (CMT). It's noon or shortly after and the RAO's AllSky camera, viewable online from campus, shows perfectly clear skies over the observatory. Real-time satellite imagery shows no chance of clouds tonight. An email goes out from the professor: "Team04, tonight's the night for you to collect your data—see you in Science B518 at sunset." Right on cue, the students are sitting in front of the workstations, logging in to the computers at the RAO that control the telescope and equipment. When the required level of darkness has been reached, they bring up a desktop planetarium program that shows where all the stars are in the sky, and they click on the target object. On the webcams they watch the telescope slew and the dome shutters open. They turn on the digital science camera, cool it down electronically, select a filter, and take a test image. If the focus is a bit off, it's quickly fixed. The star field is verified using online star maps, and in less than ten minutes, data is being recorded to the hard drive on the computer at the RAO for students to do their research project.

The telescope and camera work for many hours as the students monitor the sky for clouds and the equipment for glitches (and they work a bit on their looming assignments or exams). When the requisite amount of data is collected, they remotely stow the telescope and dome, turn off the instruments and motors, and just before high-fiving each other in celebration of a great night of data gathering, they click a button to start transferring the many hundreds of megabytes of data just acquired to their campus workstation for future analysis.

In the early days, after a productive night of observing (in the cold), the last task would be to spend about an hour copying the few megabytes of data to a bunch of floppy disks to take the data back to campus for analysis. Oh, wait, that's the second-last task. The last task would be driving home, exhausted and in the dark. Today, RAO telescopes and detectors are vastly more efficient and productive than ever, thanks to high-speed Internet and remote operation.

life in a parallel universe:

marjan eggermont

the biocene

Diatoms, mostly Arachnoidiscus. ZEISS Microscopy, 2015.

Biomimicry is design for the long term and a practice that learns from and mimics the strategies found in nature to solve human design challenges.[1] As part of a number of collaborative paths to a sustainable future such as a circular economy, doughnut economics, and regenerative design,[2] biomimicry can teach us design strategies by looking at how, for example, nature stores carbon, cycles water, harvests energy, regulates temperature, builds and protects soil, and enhances well-being.[3] We can design our cities to function as forests. We can start measuring eco performance standards in cities in an effort to determine how much soil the system is building, how much pollination happens, how much wildlife is able to pass. I have taught biomimicry as a design philosophy and methodology since 2004 to over twelve thousand engineering students.[4] And since 2012, I have designed and published the open-source, bio-inspired design journal *Zygote Quarterly*, with co-founders Tom McKeag and Norbert Hoeller, with thirty-five issues released to date.[5] The journal resulted in an invitation to present at Biocene, a series of conferences that together offer a proposal for a post-Anthropocene period in which humanity has a small window of opportunity to repair the damage done to Earth's ecosys-

76 mythologies of outer space

Biomimicry as part of the Biocene gatherings has opened the discussions to include diverse perspectives, equity and inclusion in space law, astrobiofuturists, and how to avoid repeating the mistakes of our colonial past. These discussions are key, especially with the amount of space missions currently planned. Many in the aerospace community believe we are at the cusp of interplanetary civilization in this decade and the next as we make more progress toward lunar settlement and moving out to Mars. New commercial space stations are being planned, like Axiom space station, as stepping stones toward lunar and Mars exploration. These are being called "near earth cocoons," an eerily nature-based name for one of the most hostile extreme environments. The Artemis program represents NASA's anticipated return to the Moon, including a base camp that includes a modern lunar cabin, a rover (below), and even a mobile home planned for—at the earliest—2025.[10]

Past, current, and additional upcoming activities on the Moon can be found at Lunar Open Architecture, an open road map for lunar exploration.[11] It's an evolving database that keeps track of current and future missions for lunar exploration.

biocene stories

The discussion and the intersection between biomimetics and space is currently characterized by five large themes: materials and structures for extreme environments; persistence of life in extreme environments; guidance, navigation and communication; next-generation aeronautics and in-space propulsion; and sustainable energy conversion and power. The most interesting aspects of this intersection are the stories of nature that accompany the technical solutions being discussed. Consider this example, as told to me by Konrad Rykaczewski in an interview for a special *Zygote Quarterly* issue on biomimicry and space (Rykaczewski and Zhang 2017, 98–100; silently modified):

> One of these goals [in aerospace] is to prevent icing of the airplane wings, which can rapidly change their shape leading to loss of lift, and airplanes dropping out of the sky. This is how about 600 aviation accidents happened in last 20 years of 20th century. Typically, this problem is combatted by spraying a large amount of antifreeze liquid on the airplane before or during flight. This process can be expensive and environmentally unfriendly, and also simply unreliable when we run out of the liquid (this is what often happens during snowstorms). So having a coating that would prevent ice from forming would have safety, environmental, and economic benefits.

> Since ice can form from large, supercooled droplets, one idea is to make a coating that prevents drops from sticking to the wing. In very simplified terms, "if it can't stick, it will not freeze." There are numerous examples of such "superhydrophobic" plants in nature, for example the lotus leaf, the prickly pear cacti, and just plain kale that grows in my backyard. . . .

> A couple of years ago I came up with a different idea while going on a jungle tour with my wife in Panama, where we saw this little poison dart frog. . . . I later found out that the frogs need to eat a specific type of ant to get the chemicals that are needed to make the poison. They synthesize it in a little gland in their dermis. To conserve the toxin, they squeeze it out onto the dermis only in response to a predator. The toxin then spreads diffusively in the mucus, that covers their body. That gave me an idea: how about squeezing out only little bit of antifreeze out of a coating to minimize the amount that is used. So back in the lab, we literally took the two-layer porous skin idea—except the "epidermis" was a porous superhydrophobic coating and inside the "dermis" was a "wick" filled with antifreeze. Droplets bounced off this coating like off a normal superhydrophobic coating, but when frost fills up the valleys, the antifreeze was released. At least in our laboratory tests this

turned out to work very well, saving estimated 28 fold in antifreeze as compared to systems that continuously flood the airplane with antifreeze during flight (e.g., "weeping wing" system). We also discovered that the unique combination of hygroscopic antifreeze-filled micropores inhibited nucleation in between the pores through what we call the "integral humidity sink effect." We are still studying this process, but overall this shows that it is often worth trying new systems, in this case inspired by nature, as one might discover unexpected beneficial processes.

Another Biocene presenter, Lyndsey McMillon-Brown, works on solar cells inspired by diatoms first made famous by Ernst Haeckel.[12] A solar cell's performance can be enhanced if light travels a longer path and spends more time within the photoactive layer, thereby generating an electrical current before escaping the solar cell.

Diatoms, the most common type of phytoplankton found in nature, are optimized for light absorption due to their frustules, hard porous cell walls made of silica, through millions of years of adaptive evolution. Diatoms are responsible for approximately one-fifth of the production of organic compounds from carbon dioxide on Earth and make up a quarter of all plant life by weight. They began evolving in a time when carbon dioxide was scarce in the atmosphere; the silica frustules help to concentrate carbon dioxide and allow light into the organism, increasing the rate of photosynthesis and so making diatoms one of the most successful organisms on the planet. They are also an Earth-abundant source of silica that can be incorporated into polymer solar cells without the need for complicated processing. The integration of these bio-inspired nano-patterns and designs into solar cells allows for light trapping within the photoactive layer, thereby enhancing the solar cell's absorption and power conversion efficiency.

This brings me to a third example of bio-inspired design that takes advantage of locally available resources to minimize mass and volume while launching into space. Self-Growing Habitat on Mars is a conceptual design proposal by Redhouse architecture firm and NASA researcher and astrobiologist Dr. Lynn Rothschild.[13] The idea is to send a lightweight folded and seeded "building bag" to the red planet on an un-crewed mission. Upon landing, a rover would then supply carbon dioxide, nitrogen, and water—possibly from several large saltwater lakes under the ice in the southern polar region of the planet, not from Lowell's Martian canals (page 81)—to feed algae within the sealed bag. The reaction creates oxygen and biomass and fills the form. Fungal mycelium is released that fuses with the dried algae to create a composite stronger than concrete, an

Ernst Haeckel, *Kunstformen der Natur*, 1904. Plate 4 Diatomeae.

example of myco-architecture. In addition, black fungi would be added to the bag to shield the mycelium from radiation present in space, since black fungi can survive high doses of radiation. A crewed mission takes two and a half years to arrive on Mars,[14] quite a stressful two and a half years to wonder, among other things,[15] whether your myco-architecture is still standing.

Redhouse is currently making composites of autotrophs[16] and mycelium (on Earth) that are stronger than concrete and have materials outside the International Space Station as part of the MISSE (Materials International Space Station Experiment) program, and these are being tested for space durability. Rothschild's team, in the meantime, is partnering with McMaster University in Canada to use its planetary simulator to test growth and functionality of materials under Martian and lunar conditions, since according to NASA, a future lunar landing site is the Moon's south pole, which is abundant with ice that could provide a definitive water source for myco-architecture structures.

Coloured electron microscopy of a diatom. Zeiss Microscopy, 2015. Flickr Creative Commons.

Martian canals depicted by astronomer Percival Lowell, who imagined a race of Martians constructing a network of canals to bring water from the poles to the inhabitants at the equator. 1898. Wikimedia Commons.

is biocene too late?

Recent news that scientists have created more energy from a fusion reaction than it took to create it suggests future uses applicable to space exploration.[17] This may turn the Moon into yet another resource destination, rather than a place purely for scientific exploration. A plan is in the works to start mining helium-3 on the Moon to fuel future fusion reactors on the Earth with the promise of limitless energy and prosperity for everyone and of a world free of the threats of climate change. An additional goal is fusion propulsion, which is considered necessary to open the solar system to human settlement. This would theoretically halve travel times to Mars, or make a journey to Saturn and its moons take just two years rather than eight.

We can only hope that this is not yet another set of hollow promises to secure the billions in funding needed for some space cowboy outfit. We all remember the nine-minute joyride to the edge of space taken by Jeff Bezos in 2021. What few realize is that this trip alone created more carbon emissions than one billion people produce in their entire lifetimes. With all this increased space activity and the amount of carbon emissions it produces, fusion reactors might be too little, too late. Nonetheless, Biocene is a fantastic place to dream, and the ideas that have surfaced there will be of benefit to us on this planet, especially as our own environments become more extreme.

We are, however, on a rare blue dot, one habitable world among as many as forty billion Earth-sized planets, according to a 2013 estimate based on Kepler space mission data. And in the words of Carl Sagan, "If we ruin the earth, there is no place else to go." The grass is not always greener on the other side—in fact, there is no grass on the other side.[18]

notes

1. "What Is biomimicry?," Biomimicry Institute, accessed January 10, 2023, https://biomimicry.org/what-is-biomimicry/.

2. See "What Is a Circular Economy?," Ellen MacArthur Foundation, accessed August 6, 2024, https://www.ellenmacarthurfoundation.org/topics/circular-economy-introduction/overview; "About Doughnut Economics," Doughnut Economics Action Lab, accessed August 6, 2024, https://doughnuteconomics.org/about-doughnut-economics; and for regenerative design, see Wahl 2016.

3. The website Ask Nature (https://asknature.org/) is an excellent source to explore on these issues.

4. For examples of the bio-inspired designs of my first-year engineering students, see Marjan Eggermont, "Biomimicry Drawings 2004–2010," Issuu, December 8, 2011, https://issuu.com/eggermont/docs/bio_drawing_sample.

5. All can be accessed at https://zqjournal.org/.

6. See "V.I.N.E.," Glenn Research Center, NASA, accessed August 6, 2024, https://www1.grc.nasa.gov/research-and-engineering/vine/.

7. On this concept, see also https://www.biokon.de/en/bionik/what-is-bionics/.

8. Winfield, Hering, and Cole 1991, 1-1. A pdf of this report can be accessed at https://ntrs.nasa.gov/api/citations/19920006315/downloads/19920006315.pdf.

9. "What Are the 3 Essential Elements of Asking Nature?," Ask Nature, accessed August 6, 2024, https://asknature.org/about/.

10. "Lunar Living: NASA's Artemis Base Camp Concept," NASA, October 28, 2020, https://blogs.nasa.gov/artemis/2020/10/28/lunar-living-nasas-artemis-base-camp-concept/.

11. "Lunar Open Architecture," MIT Media Lab, accessed August 6, 2024, https://www.media.mit.edu/projects/loa/overview/.

12. For a brief overview of her work, see https://www.nasa.gov/feature/glenn/2023/modern-history-makers-lyndsey-mcmillon-brown

13. The project is discussed in Scarano 2022; see also Redhouse's website at http://www.redhousearchitecture.org/redplanet.

14. For a list of crewed Mars mission plans, see Wikipedia, s.v. "List of Crewed Mars Mission Plans," last modified March 3, 2024, 09:25, https://en.wikipedia.org/wiki/List_of_crewed_Mars_mission_plans.

15. For a summary of the range of outcomes of all the Mars missions to date, see Wikipedia, s.v. "List of Missions to Mars," last modified July 12, 2024, 18:46, https://en.wikipedia.org/wiki/List_of_missions_to_Mars.

16. An autotroph is an organism capable of synthesizing its own food from inorganic substances, using light or chemical energy.

17. For an overview, see Whittington 2023.

18. This remark comes from episode 4 of Sagan's television series Cosmos. See "Heaven and Hell," Internet Archive, accessed August 7, 2024, https://archive.org/details/cosmos4heavenandhell360p.

life in a parallel universe: the biocene 83

bibliography

Rykaczewski, K., and W. Zhang. 2017. "Aeronautics and Propulsion." *Zygote Quarterly* 18: 94–111. https://zqjournal.org/editions/zq18.html.

Scarano, K. 2022. "Growing Mycelium Homes in Space." *Science Writer*, January 18, 2022. https://www.thesciencewriter.org/uncharted/mycelium-homes-space.

Wahl, Daniel Christian. 2016. *Designing Regenerative Cultures*. Axminster, UK: Triarchy Press.

Whittington, M. R. 2023. "What Will the Fusion Breakthrough Do for Space Exploration?" *The Hill*, January 8, 2023. https://thehill.com/opinion/technology/3803921-what-will-the-fusion-breakthrough-do-for-space-exploration/.

Winfield, D. L., D. H. Hering, and D. Cole. 1991. *Engineering Derivatives from Biological Systems for Advanced Aerospace Applications*. NASA Contractor Report 177594.

Lowell canals: Wikimedia Commons. https://commons.wikimedia.org/wiki/File:Mars_-_MEC-1_Prototype_-_LOC_2013593160.jpg)

chris pak

"a kind of continuous conceptual drunkeness"?[1]
analogy in science fiction

Terraforming stories can be thought of as creative experiments in imagining how we might make the future. What makes these stories distinctive are the possibilities they afford for thinking through concrete and abstract world-making endeavours across a range of dimensions. These stories are about world making insofar as they address themes related to creation and transformation. To examine and contend with the unknowns attendant on the crafting and habitation of new worlds, such stories often employ analogies to various ends, not only to familiarize that unknown but also to approach new modes of being and thought demanded by the experience of radically novel and estranging environments. These unknowns concern not only the physical aspects of adapting and living in inhospitable environments but also new possibilities for social, political, and economic arrangements that might be suited better to coping with the radically new.

Terraforming can be defined simply as the transformation of planets and other cosmic bodies to enable life that evolved on Earth to inhabit them. Geoengineering is simply terraforming on Earth. That word "simply" and the terms "terraforming" and "geoengineering" belie their ability to point to different technologies, to different ways of organ-

izing life and matter, and to diverse relationships to space and to one another, whether that other is human or otherwise.

We might conceive of the history of terraforming in science fiction (sf) as split into five periods, though it is important to acknowledge that these periods often overlap and the boundaries between them are ill-defined, and that any story that makes use of terraforming establishes a potential trajectory that may be developed by other writers widely separated in time and context. The story of terraforming that I present here is necessarily partial: prior to the post–World War II period, for example, a diverse number of terraforming works set on Earth and beyond were published. During this first period, which for convenience I label "scientific romances and interwar sf before the 1940s," terraforming and geoengineering appear in such stories as H. G. Wells's *The War of the Worlds* ([1898] 2005), in which invading Martians terraform, or more appropriately areoform, the Earth so that it resembles conditions on Mars, and Han Ryner's "A Biography of Victor Venturon" ([1909] 2011), first published in French. Ryner's short story tells of a scientist's attempt to move the Earth closer to the Sun. Because of space constraints, I will not be discussing works from this first period. The other four periods, which form the subtitles to the sections below, include "Pulp and Postwar SF of the 1930s–1950s," "Cold War and Countercultural SF of the 1960s–1970s," "The Reflective Period of the 1980s and 1990s," and "The Expansion: Twenty-First-Century SF." Terraforming stories are highly responsive to the contemporary contexts in which they are published. Such stories are just as much about the *now* as they are about the *to be*: ostensibly about the future, sf is actually about the future in the making.

pulp and postwar sf of the 1930s–1950s

Writing as Will Stewart, Jack Williamson coined the term "terraforming" in his 1942 short story "Collision Orbit." This story imagines civilization's expansion throughout the solar system, which is ostensibly united by a High Space Mandate, but which is really controlled by Interplanet Corp. This organization controls atomic power and thus wields political power throughout the solar system. "Collision Orbit" firmly associates terraforming with the twinned levers of energy and politics and turns on the search for new forms of energy that would shift this balance of power. This story asserts that science cannot be separated from society and politics: the practice of science—the attempt by the story's protagonist, himself a scientist, to develop a new energy source that would shift this balance of power—is essentially a political project that seeks to reshape the interplanetary society.

"Collision Orbit" imagines political and social relationships in terms of the colonization of the American frontier. Our protagonist reflects on how the High Space Mandate "ended the world—the frontier world that he and his kind had wrested from the cold eternal night" (Williamson 1942, 81). Against this impersonal bureaucracy is poised the "rugged little democracy" on "this far frontier against the stars" (82). Notable here is that the spatial analogy of the colonization of the American West is synonymous with a scientifically oriented mode of habitation and governance. Terraforming is not just about the material aspects of planetary modification but is also implicated in the creation and preservation of a specific social order. The scientific outpost as frontier settlement does more than structure how we think about outer space and space colonization: it also structures how we value science and engineering. When set against the "eternal night" of deep space, the scientific frontier outpost valorizes scientific knowledge and its use both for controlling matter and for transforming the interplanetary society. The frontier analogy in sf combines science, society, and the control of the physical world: this frontier is as much about using scientific and technical knowledge as it is about social relations and adaptation to new modes of being.

This use of the frontier analogy textures terraforming's representation throughout the twentieth and twenty-first centuries and forms the basis for one of the tradition's key themes. Robert Heinlein's 1950 novella *Farmer in the Sky* is perhaps the clearest example of how terraforming is imagined as homesteading, and he would revisit related pioneer themes in his 1966 novel *The Moon Is a Harsh Mistress*. Arthur C. Clarke's 1951 novel *The Sands of Mars* likewise uses the opposition between light and darkness, in this instance in relation to the creation of an artificial sun, to frame its portrayal of Mars colonization. Both stories, however, are aware of the limits of the frontier for defining the radically novel experience of space colonization. The Mars mayor in *The Sands of Mars*, for example, acknowledges the parallel between pioneer traditions and space colonization but cautions that "it can't be pressed too far. After all, men could breathe the air and find food to eat when they got to America!" (Clarke [1951] 1976, 90). The insufficiency of analogy is a key theme of terraforming stories and invites readers to adopt a critical stance when thinking about the unknown.

Judith Merril's 1952 novella *Daughters of Earth* is a generational story that places women scientists centre stage. Each generation embarks on a colonizing endeavour that takes them farther from the solar system. Sf scholar Lisa Yaszek writes that "perhaps Merril's most striking innovation, however, is to grant voice to those housewife heroines who stay planetbound while their daughters venture off to the stars" (Yaszek 2008, 38).

notes

1. Robinson 1996b, 236.

bibliography

Aldiss, Brian, and Roger Penrose. 1999. *White Mars; or, The Mind Set Free, a 21st Century Utopia*. London: Little, Brown and Company.

Allaby, Michael, and James Lovelock. 1984. *The Greening of Mars*. New York: St. Martin's Press.

Card, Orson Scott, and Kathryn H. Kidd. 1994. *Lovelock*. New York: Tor.

Carson, Rachel. (1962) 2002. *Silent Spring*. Boston: Houghton Mifflin.

Clarke, Arthur C. (1951) 1976. *The Sands of Mars*. London: Sidgwick and Jackson.

Ehrlich, Paul R. 1968. *The Population Bomb*. London: Ballantine.

Heinlein, Robert. 1950. *Farmer in the Sky*. New York: Scribner.

Heinlein, Robert. (1966) 2001. *The Moon Is a Harsh Mistress*. London: Gollancz.

Herbert, Frank. 1965. *Dune*. Kent: New English Library.

Kennedy, Andrew. 2016. "Overlords, Vassals, Serfs? How Space Colonies, the Future of the Space Economy and Feudalism Are Connected." In *Dissent, Revolution and Liberty Beyond Earth*, edited by Charles S. Cockell, 189–238. Cham, Switzerland: Springer.

Killick, Jane. 2021. *In the Shadow of Deimos*. Nottingham, UK: Aconyte.

Kowal, Mary Robinette. 2019a. *The Calculating Stars*. Oxford: Solaris.

———. 2019b. *The Fated Sky*. Oxford: Solaris.

———. 2020. *The Relentless Moon*. Oxford: Solaris.

Lovelock, James. (1979) 1987. *Gaia: A New Look at Life on Earth*. Oxford: Oxford University Press.

Le Guin, Ursula K. 1976. *The Word for World Is Forest*. New York: Berkley Publishing.

McCurdy, Howard E. 2011. *Space and the American Imagination*. Baltimore: John Hopkins University Press.

McDonald, Ian. 2015. *Luna: New Moon*. London: Gollancz.

———. 2017. *Luna: Wolf Moon*. London: Gollancz.

———. 2019. *Luna: Moon Rising*. London: Gollancz.

Merril, Judith. (1952) 1969. *Daughters of Earth*. In *Daughters of Earth: Three Novels*. New York: Doubleday.

Pak, Chris. 2019. "Terragouge." In *An Ecotopian Lexicon*, edited by Matthew Schneider-Mayerson and Brent Ryan Bellamy, 284–94. Minneapolis: University of Minnesota Press.

Pohl, Frederik, and C.M. Kornbluth. (1952) 1974. *The Space Merchants*. New York: Random House.

Robinson, Kim Stanley. 1996a. *Blue Mars*. London: Voyager, 1996.

———. 1996b. *Green Mars*. London: Voyager, 1996.

———. 1996c. *Red Mars*. London: Voyager, 1996.

———. 2015. *Aurora*. London: Orbit.

———. 2020. *The Ministry for the Future*. London: Orbit.

Ryner, Han. (1909) 2011. "A Biography of Victor Venturon." In *The Superhumans and Other Stories*, 63–7. Translated by Brian Stableford. California: Black Coat Press.

Sykes, S. C. 1991. *Red Genesis*. London: Bantam.

Wells, H. G. (1898) 2005. *The War of the Worlds*. London: Penguin.

Williamson, Jack. 1942. "Collision Orbit." *Astounding Science Fiction* 29 (9): 80–106.

Yaszek, Lisa. 2008. *Galactic Suburbia*. Columbus: Ohio State University.

science fiction that might have been, or the outer spaces of the gibson collection of speculative fiction

stefania forlini

Pile of Gibson Compilations featuring Gibson's own numbering (photo: Stefania Forlini). With thanks to the University of Calgary's Archives and Special Collections for permission to reproduce these images.

Gibson Compilation no. L83

Among the many odds and ends in the massive Bob Gibson Collection of Speculative Fiction held at the University of Calgary, there is the cover of a 1952 issue of the Canadian edition of *Time* magazine with the caption "SPACE PIONEER: Will man outgrow the earth?" The cover illustration is a familiar one even if you've never seen it: a large three-legged robot appears to explore an unknown planet with strange rock formations on its surface while a ringed planet (perhaps Saturn) looms large in the sky above. The caption ties the image to a tradition of science fiction entangled in colonial expansionism and assumed technological mastery over the future of "mankind." Culled from the original magazine for inclusion in one of the more than 880 hand-crafted anthologies of speculative fiction produced by Gibson himself, however, the image is also recontextualized. It now lives in a collection that features the "stereotyped imagination" (Gibson n.d., Compilation no. 49) of science fiction (sf) and related genres as well as science-fictional oddities at the outer edges of one of the most popular, enduring genres of modernity.

For those unfamiliar with the Bob Gibson Collection of Speculative Fiction, it is worth noting that his more than 880 hand-crafted anthologies[1] are but a relatively small—if also unique—part of a much larger collection of more than 30,000 items, including hard- and softcover books and complete runs of hundreds of pulp magazines. The fanzine-like anthologies constitute a kind of homemade archive; they are instances of "reading with scissors" in the vernacular practice of scrapbooking (Garvey 2012, 11). Collectively they exemplify the carefully curated work of a collector with "scavenger sensibilities" (Leslie 1999, 89), one who sees value in preserving things others would simply throw away. Gibson was not a collector of fine first editions; a Calgarian of modest means, he was an avid, lifelong collector of the everyday—that is, the everyday ways science-fictional modes of future-oriented speculation infiltrate cultural imaginaries.

As is apparent in his anthologies (and the marginalia sprinkled throughout them), Gibson read through hundreds of popular British, American, and Canadian periodicals from the 1840s through to the 1990s, carefully cutting out specimens of sf and related genres. He reorganized his cuttings with other pieces similarly harvested from the same (or similar-sized) periodicals, then bound them with glue and/or staples complete with scrap-paper covers of whatever paper he may have had at hand. The covers are adorned with bibliographical details in a handwritten table of contents and often (though not always) with Gibson's own hand-drawn illustrations. Though most anthologies bear the title of their source periodical(s), two of them named "Scraps" (following page) perhaps best showcase what they all have in common: their collection of scraps that gesture beyond themselves literally and figuratively.

Among these scraps, there are treasures that refract dominant tendencies in the science-fictional habit of future-oriented speculation and its testing of "horizons of possibilities" (Csicsery-Ronay 2008, 1). Consider, for instance, some particularly compelling instances in which Gibson justifies (as he sometimes does by writing in the margins of his anthologies) his reasons for including a particular piece in what he refers to as "the province" of his collection (Gibson n.d., Compilation no. 87). Among the carefully gathered and curated scraps, there is a work labelled as "a science fiction tale that might have been." This note is written in the collector's own hand about a story by early feminist author of fantasy and sf C. L. (Catherine Lucille) Moore that he collected from a 1935 issue of *Weird Tales* (see p. 101).

Selected Gibson Compilations featuring the titles of the source magazines (photo: Bridget Moynihan).

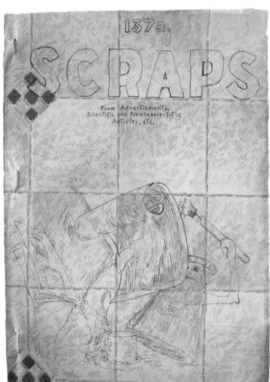

Left: Pastings on *Tomorrow's City* folded out of 137a.

Below: Gibson Compilations no. 106a and no. 137a. *Scraps*.

science fiction that might have been 101

The story "Jirel Meets Magic" is one of a series with all the tell-tale signs of a particular tradition of fantasy. It features magic, wizards, and battles in medieval-like settings. So why would Gibson, a highly knowledgeable and particularly industrious sf fan, select it as a specimen of "a science fiction tale that might have been?". One can only speculate based on the clues available. Perhaps the most compelling of these appears at one point in the story when Jirel, a "warrior lady" intent on wreaking revenge on a wizard who attacked her people, enters a strange room in a sorceress's castle whose walls are studded with "innumerable doors" (41). Each door appears to open onto an alternate world, alien being, and/or alien experience. From the "terrifying glimpse of starry nothingness" (43) shown through one door to the "denizens of . . . strange worlds" (47) she glimpses in others, Jirel stands on the threshold of outer space, each door a portal into "other lands and times and worlds" (43) full of "alien things, shapeless monsters, faceless, eyeless, unrecognizable creatures from unknowable dimensions" (48). The view from each door suggests innumerable other possible stories that readers might begin to imagine as Jirel pauses at each threshold.

Gibson Compilation no. 70.

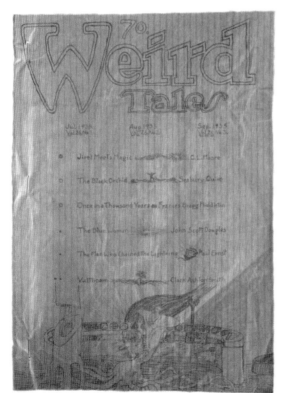

Is it because she glimpses but does not step into these strange worlds that this is sf that might have been? Or is it because these portals that provide access to other worlds are the implied work of magic (rather than some concoction of science and technology)? Or is it because the other worlds are neatly stored behind doors in the first place? After all, an sf fan like Gibson might well suspect that the starry nothingness of outer space, the alien beings of alternate worlds, and/or alternate times are never neatly encapsulated and often intrude without warning or perceivable threshold into the present world as we

think we know it. The thresholds in this scene of the story appear clear-cut, a doorway, a clear division between here and there, this world and that, but in the world of the story and the world of Gibson's collection (and possibly in the world of literary history more broadly) thresholds are messy places, tangled brush in tangled woods, and the tangles are rich with stories and unexpected crossovers. Gibson may appreciate the view from the threshold between fantasy and sf that Jirel's pauses afford him, but he also seems finely attuned to the ways that sf often untidily mingles with other genres—fantasy, detective fiction, horror, the weird, to name a few. Gibson's collection helps preserve this generic richness in this and thousands of other pieces.

Take for instance another (misleadingly simple) threshold moment highlighted by Gibson, this time from the pages of Charles Dickens's popular weekly periodical *Household Words* (1850–9). In the margins of "Our Phantom Ship on an Antediluvean Cruise" (1851), Gibson leaves a note that appears to identify an unexpected but momentous literary-historical leap when a serial travel narrative turns into one of time travel: "Its previous trips were geographical only." Clearly Gibson had read the whole series, spread across several numbers of *Household Words*, but he selected only this last episode for inclusion in his collection, specifically for its foray into time travel. So, what launches the Phantom Ship whose "previous trips were geographical only" into time travel for its last voyage? From its first line, the piece explains that the ship had no choice but to try something new since it finds itself suddenly outdated: "Now that we can visit any portion of the globe by taking a cab or an omnibus to Leicester Square, who wants a Phantom Ship to travel in?" (492). The Phantom Ship had been outdone by a competing popular visual display of the Earth: Wyld's globe, a massive globe built to scale (ten miles per inch), originally intended for the Crystal Palace. Because it was too big(!), it was instead set up in Leicester square (Black 2000, 29), precipitating the Phantom Ship's final voyage.

In this scrap, we glimpse how common narrative forms (in this case a travel narrative) branch off in new directions under market and intermedial competition of the broader media ecology of science spectacles popular in Victorian Britain. Because "the world as it is, has taken a house in London, and receives visitors daily," readers are told that the Phantom Ship has "no choice" but to travel into the future or the past (492). If the ship finally decides to set sail on an

science fiction that might have been 103

antediluvian cruise into the distant past, it is, readers are told, because a Phantom Ship is unlikely to survive the future. It is perhaps the very possibility of travel in time that appeals to Gibson; maybe more specifically this initial tantalizing teetering on the pivotal decision between travel into the future or travel into the past compels Gibson, a reader with scissors, to snip this piece out for his scrapbook archive of sf. The moment is one to savour, even if it is perhaps more meaningful in retrospect than it may have been for its own time when the ship's decision to go back in time appears a clever and pragmatic one, rather than one with implications for the emergence of the then new genre of "science fiction"—a term whose first recorded use appears the same year (1851).[2] As interesting as this unexpected foray into time travel might seem in retrospect, the full import of the Phantom Ship's final voyage cannot be appreciated out of the context in which it first appeared.

The Phantom Ship's previous trips (earlier episodes in the series that Gibson had clearly read but chose not to include in his collection) were to explore "remote" places, including parts of Africa, Central America, the Arctic and Antarctic, China, and Japan. In these previous voyages, which read like a cross between guided tours and capitalist surveying of opportunities for "civilizing commerce," the Phantom Ship is a device used to bring the world "home" to a British audience; it functioned much like the great world exhibitions such as the Crystal Palace, or even individual exhibits such as Wyld's globe, which offered the British opportunities to "[master] the globe in an afternoon" (Luckhurst 2012, 388). The mastery promised in the Phantom Ship's earlier voyages is, however, undermined by the final one in which readers recede in geological time to the very edges of the "bounds of life" and the "bounds of knowledge" (495). The piece brings readers to the farthest reaches of the then known history of the world and its species and allows them to peer out toward what they *cannot* know, *cannot* master, what they can only speculate about. Here, much as at the thresholds of Jirel's many doors, readers glimpse the edges of something beyond which the narrative does not go, but to which it nonetheless provides an opening. Such incidental, anonymously published periodical-based works such as the Phantom Ship series are unlikely to get even a marginal mention in histories of the genre of sf, but because Gibson gathers such seemingly one-off instances by the thousands, the weight of aggregation shifts received histories of the genre that for a long time traced major authors and major works while neglecting all the small ways the genre co-evolved with emerging mass audiences.

In selecting works Gibson seems to recognize that sometimes related genres contain the potentiality of branching in new directions such that sf may appear lodged like a

Gibson marginalia from Gibson Compilation no. 336, *Household Words*.

Zoology include, for instance, the Zoom (included in Gibson) as well as the Two-Tail Sogg, who prefers to remain in "Regions / Of Fancy / Remote," or the Snaitsh, who seems no less a beast of fancy but whose "fossil debris" might be found on "the Priamaeval Shores / On an Eocene Sea / or / In slabs / Of the old / Miocene." If this mingling of fantastical and evolutionary beasts in Sime's Zoology seems a quirk of Sime's, it is worth noting how common it was in Victorian Britain to see fantastical elements in science and to reconsider fantastical beasts as having their basis in evolutionary science. It is something of a stock theme of the early works collected by Gibson, the earliest of which come from *Chambers' Edinburgh Journal*, a cheap weekly that sought (among other things) to bring "the treasures of scientific knowledge to the people at large" (Chambers 1832, 130) at a cost even the poorest labourer could afford. In these earliest works that Gibson harvested, there is evidence of writers stretching science writing in the directions of popular fiction to help engage a largely uneducated audience in the "wonders" of science.[5]

If Sime's Snaitsh appears at the intersection of science and fairytale, the Wily Grasser might seem a resident of wonderland: he "Sit[s], / Where / The Wuffle Wood / Leaves a lot / And Barks / A Bit / Like a grown wood should" and asks "with an air / of doubt— / Can you tell me true / Tell me / When the light goes out / Where / It goes out to? / Tell / Oh tell me / What the Days / Change to / When they're done, / Tell me / Where tomorrow stays / While / It's unbegun," before moving along on his way without waiting for an answer.

The similarly elusive Moonijim is doomed to wander "in a remote dimension" such that he is "neither here nor yonder." Moonijims "dawdle / Only in those outer spaces / So far apart / From all the other / Places, / That lie / Outside / Your furthest thought / Between / The Is and Not. / Oh! / Things / Crawl there / That never dare / Seek / Any other spot." The lines "Between / The is and not" could be one way to think about where sf lives, and sf illustrations provide glimpses of who and what might be found there.

Here now we've gone from the outer spaces of the collection into works beyond it, but this may be part of the value of scraps for a collector with scavenger sensibilities such as Gibson. Each scrap may be a piece of detritus from another time, but it is also a whole world unto itself, or a wormhole to an unexpected dimension of story and/or literary history. The works contained in pulp magazines such as *Weird Tales* or cheap weeklies like *Household Words* and *The Sketch* were not meant to last; they were inherently transitory, printed in a disposable, cheap, machine-made-paper format for mass consumption. Gibson not only diverted these works from their planned obsolescence, but

Sime's cover and spine design for Machen's *House of Souls* (1906).

ZOOM

science fiction that might have been 109

MOONIJIM

TWO TAIL SOGG

110 mythologies of outer space

SNAITSH

WILY GRASSER

revalued, repurposed, and transformed them—such is the work of the scavenger collector like Gibson who sees and preserves the value inherent in the science-fictional offshoots in the outer spaces of a stereotyped imagination.

Some critics claim the "science-fictional" is part of a late stage of sf genre development in which it overspills its bounds into everyday life, becoming a "way of thinking about the world" (Csicsery-Ronay 2008, ix) based in an awareness of technological change and the testing of "horizons of possibilities" that such change suggests (Csicsery-Ronay 2008, 1). However, others claim the science-fictional is not symptomatic of a late stage of the genre, and that instead it has been there from the very beginnings. This may be why it appears in explications of scientific knowledge and discovery (contained in the earliest works harvested by Gibson from the 1840s onward), a time when, as Melanie Keene has shown, fairy tales were "made to look a lot like science," even as science could look "a lot like fairy tales" (2015, 6). As scientific discoveries—or, more accurately, the broad and unprecedented dissemination of scientific discovery in a language accessible to most who could read or be read to—estranged the world as people thought they knew it, genres blurred to help make sense of it all.

There is in these transitional moments a letting go of a world in order to grasp it in a new way—and in that letting go all the exhilaration and fear of being ungrounded, untethered, and free, but also dangerously precarious. Marshall McLuhan once claimed that "the spoken word was the first technology by which man was able to let go of his environment in order to grasp it in a new way" (1964, 57), but since then many more technologies, real and imagined, have offered such an opportunity. You might picture this transition as swinging from vine to vine in some imagined jungle—you have to swing and let go of one vine in order to move toward and grasp the next, but for the briefest of moments you are suspended mid-air with no tether, no palpable ground and only the very real possibility of falling. This moment is a kind of opening, the loss of something not yet fully felt, the start of something not yet there, a crack in the everyday in which something else entirely might enter, shifting, refracting all our befores and all our afters. Of course, the swinging-from-vine-to-vine image doesn't really work since, when it comes to human experience, one never really let's go of anything, but brings it along; our world is the messiest of archives. Scraps of earlier worlds are everywhere, whether or not we are attuned to read them. Every new way to grasp the world must for a time contend with all the old ways and transform and be transformed by them in turn. It's a messy business much more akin to a process of mutation, contamination, transformation into something none of the befores could predict but without which they could not become something else.

notes

1. While officially referred to as "Gibson Compilations," I employ the term "anthologies" to accentuate the curatorial and editorial work performed by Gibson as an "expert amateur" (Hayles 2012, 36).

2. Critics often note (and just as often dismiss) the fact that the first instance of the term "science fiction" appears in William Wilson's *A Little Earnest Book upon a Great Old Subject* (1851), which defines "science-fiction" as a kind of writing that employs fiction "as a means of familiarizing science" (137) by interweaving the "truths of science" with "a pleasing story which may itself be poetical and true—thus circulating a knowledge of the Poetry of Science, clothed in a garb of the Poetry of life" (138–40). While this definition seems unfamiliar by twentieth- and twenty-first-century understandings of the genre, it points to a kind of writing that was very common in the nineteenth century and may point to one of the many "origins" of the sf genre. For details, see Forlini 2022.

3. Drawing on the work of Ernst Bloch, Matthew Beaumont argues that "effective sf can demonstrate that an inchoate future is already germinating in the present, changing it, and making it other than itself" (2006, 230). I suggest that such germinating change appears in genre transformations as well, with familiar genres containing within themselves new generic possibilities harnessed for the needs of particular moments, such as when the Phantom Ship tries to keep readers' attention when in competition with Wyld's globe.

4. In a 2008 issue of *WCSFAnzine: The Fannish E-zine of the West Coast Science Fiction Association*, Bob Gibson "of Calgary" (The Graeme 2008, 13) is identified as a well-known, influential fan and fan artist of the 1940s.

5. Details about these early attempts can be found in Forlini 2022.

bibliography

Beaumont, Matthew. 2006. "Red Sphinx: Mechanics of the Uncanny in 'The Time Machine.'" *Science Fiction Studies* 33 (2): 230–50.

Black, Barbara J. 2000. *On Exhibit: Victorians and Their Museums*. Charlottesville: University of Virginia Press.

Boyd, Melanie. 2010. "The Bob Gibson Collection of Speculative Fiction at the University of Calgary." *Science Fiction Studies* 37 (2): 180–1.

Chambers, Robert. 1832. "Popular Information on Science." *Chambers's Edinburgh Journal* 26 (May): 130–1.

Csicsery-Ronay, Istvan, Jr. 2008. *The Seven Beauties of Science Fiction*. Middletown, CT: Wesleyan University Press.

Forlini, Stefania. 2022. "Periodical Speculations: Early 'Science Fiction' and Popular Victorian Weeklies." *Science Fiction Studies* 49 (1): 1–31. https://dx.doi.org/10.1353/sfs.2022.0003.

Garvey, Ellen Grubar. 2012. *Writing with Scissors: American Scrapbooks from the Civil War to the Harlem Renaissance*. Oxford: Oxford University Press.

Gibson, Bob. n.d. Compilation no. 106a. *Scraps*. Archives and Special Collections, University of Calgary, Calgary, Canada.

———. n.d. Compilation no. 137a. *Scraps*. Archives and Special Collections, University of Calgary, Calgary, Canada.

———. n.d. Marginalia. Compilation no. 87. *Blue Book*. Archives and Special Collections, University of Calgary, Calgary, Canada.

———. n.d. Marginalia. Compilation no. 49. *Doc Savage*. Archives and Special Collections, University of Calgary, Calgary, Canada.

———. n.d. Marginalia. Compilation no. 336. *Household Words*. Archives and Special Collections, University of Calgary, Calgary, Canada.

———. n.d. Marginalia. Compilation no. 70. *Weird Tales*. Archives and Special Collections, University of Calgary, Calgary, Canada.

The Graeme. 2008. "Bob Gibson: 1940s Canadian Fan Artist." *WCSFAnzine* 6 (February): 13–16.

Hayles, N. Katherine. 2012. *How We Think: Digital Media and Contemporary Technogenesis*. Chicago: University of Chicago Press.

Keene, Melanie. 2015. *Science in Wonderland: The Scientific Fairy Tales of Victorian Britain*. Oxford: Oxford University Press.

Leslie, Esther. 1999. "Telescoping the Microscopic Object: Benjamin the Collector." In *The Optic of Walter Benjamin*, edited by A. Coles, 58–93. London: Black Dog.

Luckhurst, Roger. 2012. "Laboratories for Global Space-Time: Science-Fictionality and the World's Fairs, 1851–1939." *Science Fiction Studies* 39 (3): 385–400.

McLuhan, Marshall. 1964. *Understanding Media: The Extensions of Man*. New York: McGraw-Hill.

Wilson, William. 1851. *A Little Earnest Book upon a Great Old Subject*. London: Darton and Co.

kyle flemmer

stellar sequence

Stellar Nebulae

B ou n d　　　in　　　heav　ing

　　　Voids　　of　　　fo　　rm　,　a

Sub　tle　　　shro ud　—　　sub-

　　　　Mo　　lecule　　s　　　　in

Hydr　o　　　stasis　.　　　A

　　　No　　ma　　ly　　　ra　l lies

Rem　nant　　no　　vae　—

　　　In　cites　　ig ni　tio　n　.

Pro

Brown Dwarfs

"Twinkle—

 Twinkle
Little substar—

 Glowing sick
Magenta red—

 Mourning
Futures—

 Dashed by
Particles—

 An errant
Translocation—

 Some place
Dire—

 Where
Doctors kill—

 People who
Are people—

 Nonetheless."

Red Dwarfs

Revolution violent
As a bread riot,

As the butter
Of wartime

And bellies aching
For bacon.

No amount of flag-
Waving fills us.

Another democracy
Is decreed

In response to each
Terrorist act.

Today you will
Be called upon

To report your
Mother.

Become an agitator.
There are no

Clean hands, no
Innocent bystanders.

Just remember
Who has the right

"To words—

And when every
Poet is in exile,

Who stashed
The razors

—Hidden in our soles."

Orange Dwarfs

Imagine a multitude of worlds
Lurking in the dark,

Idyllic astride un-ionized
Waves enriched with DNA.

They resonate in harmonies
Of mathematical precision.

One day we will walk hand
In hand, like children,

Over their abundant ground.
Until then, our fixation

Remains Ptolemaic. We
Make a science of all

That is wrong, forget quanta
Derived indirectly

"Are never confidently known."

Estrangement is a virtue
Among xenophobes,

Those rude and wild people
Who think in pointed thrusts.

Facts fail or prevail
In their telling.

"I suspect a too-perfect world."

Even in Arcadia there is
Treachery, abduction,

And a body catching bodies
Coming through the rye.

We live so we can learn
To regret pre-emptive strikes.

Yellow Dwarfs

On sunny battlegrounds
Opposing protons co-immolate—

Solar monks bellowing
"Let there be light!" as they

Collide. Material causation
Becomes religious preoccupation,

Fusion our respite
From the Kingdom of Darkness.

Ignorance blisters, but
Factions illumed cannot yet see

"How pride conceals cowardice."

Words cleave matter
Into boxes of sound, and still

We are plasmic
Shrapnel of incendiary rounds.

Blue Giants

Giants' fated death is chemical, might our
Petty dictator. We shrink or shed, choking

On the fumes of a looming detonation.
Scatter chromatic ash, oh unborn stars,

"Our death drive a birthright—

We fleeting zeppelins hang inflamed from
The firmament rafters, faithless balloons

Guzzling buoyant bowels, our skins rent by
Limited reactants as by the nails of harpies.

Light a match in this henge squeezed of
Blood and our failure will look like success.

Worldly possessions dispensed with,
We claim it is

 —Because of love."

Because love moved on, dishonor moved
In, or to part with guilt-spotted hands,

We take the orange tips off plastic rifles
And point them at cops. Release railings.

Swallow buckshot. Unseal our helmets
Before the Gates of the Maker.

It is better to burn on a pyre by design
Than fade under sail into a deeper blue.

Red Supergiants

One hundred thousand heads down
The slick pyramid steps, no sign

From God just yet, only this house
Fire of contested land, this linguicide

Standing dead-eyed in the bloody
Money, a shell of fusion consuming

Scarcity at its core. Hydrogen fuels
Ambitious destinies. To grow is to

Cannibalize our own. Rome also
Bloated in decline, a corpse king

Rat, red in tooth and famous. Never
Forget how the soldiers took aim

Over the heads of your enemies.
Now, incentivize the kill. We offer

Hit point multipliers and college
Scholarships for
 —Running riot!"

"Fatality—
 And an officer's salary
If you can stay cool under pressure.

As oily-fingered bureaucrats
Draft their depositions, we deploy

In massive crimson waves our
Highwaymen and slavers, sent to

Plow your garden like Cunégonde.
Choose a heath to die on in this

Roiling supercell. Booted troops
Amass behind a border wall,

Awaiting the attrition. Already
Reporters are avoiding embassies

And stadiums. Already we jettison
The outer strata, mistaking margins

For machete silhouettes. So . . .
What's a tontine among friends?

Yellow Hypergiants

They say great stars are quick to burn,
Great worth makes one unstable,

And fearless Ozymandias despaired:
"No power springs eternal."

But, me? I'm supernumerary. A Sun
King rare and rarified.

Philanthropist. A luminary. Hear my name
At Clippers games.

I'm on the news, devoid of shame.
I'm on the flight logs

Reciting sonnets to my yacht, a tanka
To my rocket. Watch!

One mad tweet, my tankies dox
The offspring of my rivals.

Nepotistic patriarch of aquafers and fools,
A coked-up Dauphin

Going nut nut in the family pool.
I'm an Emerald City oligarch

Flipping condos by the billions.
Disaster bubble profiteer,

My bullion building to the ceiling.
I'm minting

Countless NFTs like a latter-day Croesus,
A diamond-handed Jesus

Holding Dogecoin FTW. I am liquid
Nebulosity, a human

Rights atrocity with enough cake
To end world hunger.

Instead, I sic senators on swing states,
Then contemplate decay.

Black Holes

Oh censored sovereign, oh Satan! Spur me to write what
I am afraid the future may read. Deliver the incantation

Which splits this poem, lend it your shape and purpose.
(Un)purpose: to (un)say, (un)make, (un)be. Dear Satan,

Who lies in deep Hell's obscurity, hidden be thy name.
May warp'd waves lens the black dog b e y o n d

—*An 'orizon of fallen suns."*

May end times come to countries without emigrants,
Their searing tongues lick obscene at the altar of ape

Familiars. Hail Satan, full of matter, pull me from the
Narrow sunbeam of my linear obligation, from this

Ethic of normative being. Take me into the confines
Of your love. Take space, take . . . time.

Take me into your most secret garden, for hemlock
Pales to the crush of adrenochrome as libertines

Burn the evidence. But how to know the essence
Without an outward sign? Consult a daimonion of

Fate or principle. Listen closely, it whispers
Hail Satan of radiant economy, God abhors

Your naked maw like the supermassive
Suck of an entry wound. Asymptotic

—*A mnemonic without object."*

Oh, engine of annihilation!
Oh, Charon! Shuttle me

Down to bottomless
Perdition where

The whole is
Reduced

To a
.

Carbon Stars

Ruby rays run from a sackcloth hood,
Sooty and oxygen-bare.

Like clockwork, Justice dips her thumb.
It is willed, though we

Condemn you to we know not what.
Every villain stretches

For your alleged crimes. Would that
Lines between victims

Were clear. Confess to passing strange
While breathing in

Your neighbor's carbon, its compression
Chamber heat-glow

Daily darkening your soul. Deprivation
Diagnosed, now,

Deviant, step around the puddle
Into righteous fusillade.

Make peace with your hour as divined
By peerless jury

When—

 "Chalo!"

 —The burnt umber afterimage
Transits panoptic nerve.

Witness hellfire convect in flesh, mercy
Rolled up into skull

As three megajoules of ablution
Sanctify the body's temples.

White Dwarfs

Our first microsecond contains
The grain containing everything

Else. An expanding cloud of subatomic
Particles, condensing hydrogen densities

Collapsing into stars. Furnaces fed
By gravity, weighted with rings

Of cosmic debris precipitating
Planets like bubbles 'round a drain.

"Life exists on radiation,
We're a solar fermentation—

Chlorophyll thieves defying entropic
Degradation of culture with Art,

Hegelian data miners inscribing poetic
Manifestations of Spirit in stone like

Roland beating his sword: brains spilling
From the ears while gripped on the wrist

By an angel. I am an old star imploding
In tearful pirouettes, called to here-

After by an excess energy, my true face
Hidden behind the cracked Grecian urn

Out of focus in the foreground. News is
White dwarfs are special, but we are all

 —A little flicker of matter."

Black Dwarfs

Ember-wasted
 Awful twilight

Nearing final
 Sunlit ruin.

Horizons ebb

 "Like memory."

After kinship—

 Sputter, halt.

Protons melt.

 The endless

Howling record

 Spun out.

elyse longair
in conversation with naomi potter

Elyse Longair, *Surveillance Operations Post*, Collage, 48" x 35.4", 2023.

This interview took shape over several email conversations between Elyse Longair and Naomi Potter from August to October of 2022, and focused on the artist's collage practice as well as her ongoing interest in sourcing photographic imagery that speaks to imaginary worlds, alternative futures, and worldbuilding.

naomi potter: Both instruments and machines in these images are clearly analogue; the banks of dials, levers, phones, and monitors—all part of a complex system of monitoring human exploration of space. I see a kind of parallel in the process of collage, yet these images are not made from cutting up paper and gluing fragments together to make images. Rather, they are also made digitally, which makes a very analogue process much more seamless and, to some extent, more believable. These images look like the illustrations of a science fiction novel, but they also look very believable and real, as if they were taken from a documentary. Can you comment on your use of collage, digital manipulation, and the fine line between fiction and reality these images evoke?

elyse longair: My collages are created analogue, by hand, which requires a lot of time spent studying what images are and searching for possible relationships to reimagine beyond the realities and meanings of the "original." At the most basic level, I see an image as a representation that points to the world in some manner, which for me is important because images do not simply re-present "the real" but, especially in contemporary culture, they create our sense of reality. In other words, images are carefully curated pauses in time, capturing a specific edited vision of history and reality. My interest is in what could exist beyond that moment, outside the frame of the image.

You bring up something interesting that I think about a lot, which is the reality or the believability of my collages. Like Max Ernst, my aesthetic embraces a seamless, flat quality that allows the viewer to imagine freely the possibility of the image. I accomplish this by scanning my collages to eliminate the cut lines and reduce the colour and texture variances. I find limiting the source material also pushes the viewer to negotiate between the obvious images and those that are more subtle. Once scanned, I spend around eight or nine hours, sometimes more, working with each collage onscreen. I zoom into the pixels and erase any dust, scratches, or damage and clean up any noticeable cutlines before printing my work large-scale for exhibition. One of my mentors, Dr. Julian Haladyn, was surprised and fascinated when he learned I keep my analogue collages as fragments to reuse images from both the front and back of the original. What interested him, and something I appreciate, is how the scanner unifies the fragments, which makes the final printed collage both a presentation of the merged fragments and a representation of the analogue composition.

np: These collages embrace a kind of nostalgia that can often be found in science fiction; they contain images that are both speculative in imagining a futuristic blending of science and technology, while they are also deeply rooted in the imagery of space exploration that was driven by the Cold War and the space race between the Soviet Union and the United States in the late 1950s and early 1960s. What draws you to the images you use? And what is the source of these images?

el: I continually build an archive of images sampled from our image-rich world, specifically popular knowledge source material—ranging from *National Geographic* (often from the seventies, eighties, and nineties) to contemporary issues of *Vogue*. Searching for images in magazines is very different than searching for them online. I enjoy the material randomness that occurs when I flip through them. I come upon things much more randomly, in a sense, and I can more easily see the possibilities within images. I rely on my

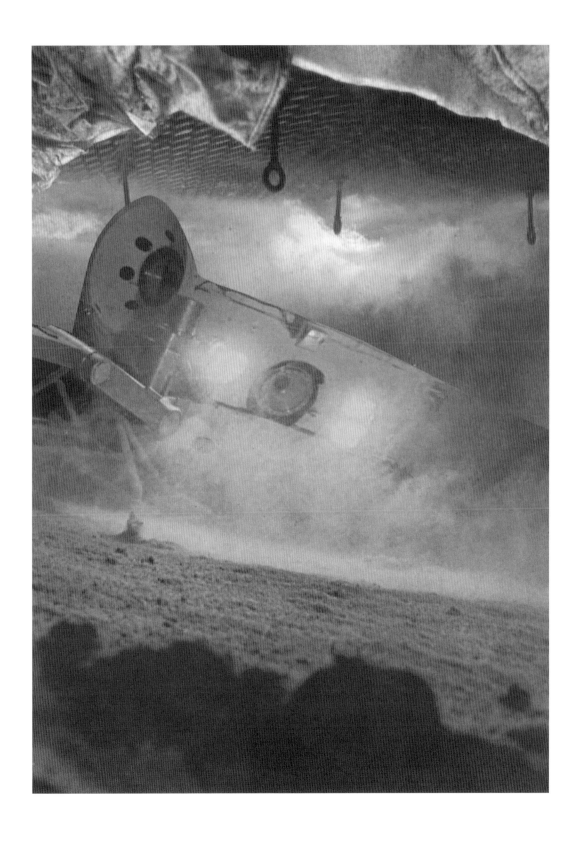

134 mythologies of outer space

Elyse Longair, *Quantum Energy Port*, Collage, 48" x 40.5", 2018.

elyse longair in conversation with naomi potter

Elyse Longair, *Mission Control*, Collage, 48" x 40.2", 2020.

insignificant in scale compared to the infrastructure, machines, and aircraft that allow them to move, survive, and ultimately thrive in space. I wonder if this comes from the incomprehensible scale of space itself, and when we try to imagine ourselves in this vastness we are often left with our insignificance. How do you think of scale in this work?

el: Science fiction films and their language are often brought up in conversations about my work. For me, this means that the worlds I build are strange enough and yet still have a glimmer of possibility that the viewer wants to adventure into them—in a similar way to what a good science fiction film does. My collages require substantive space in order for the world to function properly. Any kind of spatial configuration that feels constrained, I work against. It is also necessary that the scale within my work is convincing. I show multiple perspectives, illustrating the vast landscapes with tiny humans or little to no human presence at all, while other times I show the viewpoints from up close, from more familiar human perspectives, so that the worlds feel plausible.

When exhibited, my work also requires space, with clear sightlines and breathing room around each image. It is necessary for someone to stand in front of the work to fully experience it. I encourage others to spend time with the collage; it is not the immediacy of the image that interests me, but rather the possibility of multiple meanings that can only be accessed through intentional, focused viewing and imagining.

np: Commercial space mining is a very real possibility in the future. In 2020 NASA awarded contracts to four companies to extract small amounts of lunar regolith (dust, soil, broken rocks from the surface of the Moon) by 2024. The idea of heavy industry and large-scale resource extraction moving to space is dangerous, as agreements governing these emerging interests from a long list of countries are part of an outdated treaty framework developed during the Cold War which essentially leaves property and mining rights unregulated and open for exploitation and abuse, as well as opens the door to larger environmental and political consequences. Many of your images show industrial processes that generally are left vague so we are not sure of the details, but are simply given a vaporous glimpse at process. Can you speak to this?

el: You point to something which is very important to my practice, which is nuance. I give the images subtlety and space to take on different meanings, to open up the possibility for alternate experiences. Yes, industrial commercial space mining might be hinted at, however, I lean into my intuition when I collage, and I let the images come together. When I have a targeted agenda in mind, the collages feel very forced, con-

Elyse Longair, Specimen Control, 48" x 46.8", 2020.

elyse longair in conversation with naomi potter 137

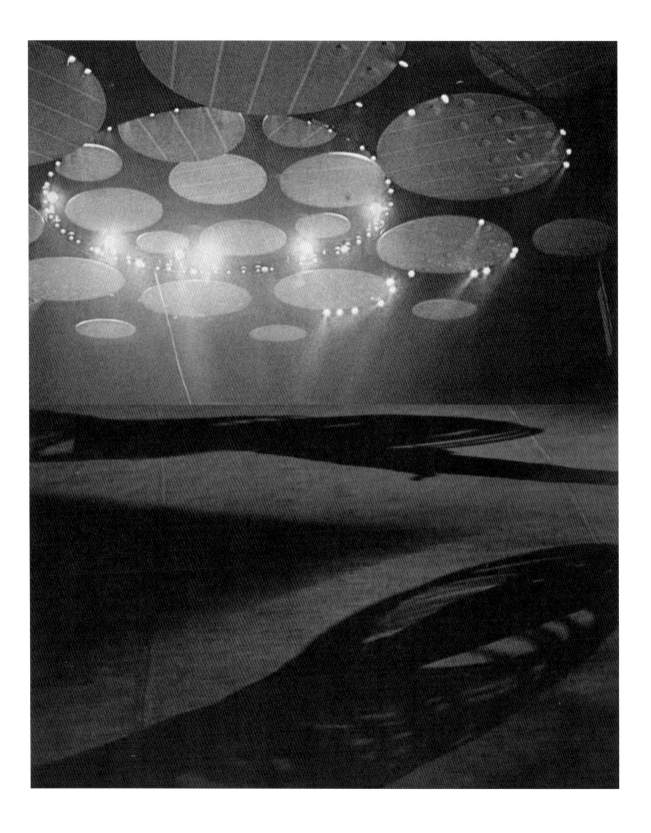

strained, and unsuccessful. What I'm reading, what I'm looking at, or what I'm thinking inevitably trickles into my imagery, and at times I am not aware of this until much later. Through leaving my collages vague, the viewer, to go back to Duchamp, holds the Creative Act to interpret the image, to complete the image, and, if they wish, to enter the image and my imaginary worlds.

np: Terraforming is the process of making other worlds habitable for human life, and it was one of the topics of this forum. Fuelled by science fiction, and now driven by climate change, this speculative promise of creating new worlds is at once filled with hope, but also points to a lack of responsibility to care for the planet we do inhabit. So, while off-worlding, parallel universes, and time travel do offer the promise of escape, should we not consider why we are looking at escaping first? Are your images about escape?

el: A parallel term I often use to talk about my work is "worldbuilding," which is still a relatively new academic discipline. Worldbuilding, to put it simply, focuses on the world itself, as opposed to the primary attention being placed on characters and their narrative development. In science fiction, since around the nineteenth century, we can see worldbuilding strategies used to question and criticize how humans treat planet Earth, and to create a conceptual space to imagine alternative futures. I take a similar approach through science fiction collage in which my aim is to explore how fragmented worlds of a reconstructed past may question our notions of linear time and reshape our thinking of future possibilities. Focusing on imagination, rather than escape, I hope that perhaps we can create a brighter future for our planet by considering alternate futures from the past or collectively imagining possible distant, more promising futures.

Elyse Longair, *Rise Again*, Collage, 48" x 39", 2020.

dianne bos

galaxy series

While working with traditional photographic techniques for over forty years, I've evolved varied thematic bodies of work and merged technical innovations to create new visual hybrids. The resulting innovative uses of pinhole, film, camera obscura, photogram, installation, and cyanotype all explore the world around us and play upon intersections of artistic production with scientific research and discovery.

Pinhole photography allows me to create my own unique camera object and suggest a relationship between it and the image it makes: a book on the West photographs the Western horizon, a galaxy of pinholes creates a new universe. In 1999 I began experimenting with these "homemade" cameras, which allowed me to understand and play with aspects of light beyond what my eyes see—to render visible that which cannot be seen.

And since I couldn't get into space, I had to invent my own pinhole camera to help speculate about and interpret the sources of light. In a pinhole camera, light travels through the lensless, pinhole-sized aperture to project an image, upside down and backwards, onto the back of any light-proof container. Multiple apertures project multiple images. If the container has photosensitive paper or film inside, that image is recorded as in a lens camera, but over much longer exposure times.

I've been able to explore time and space from my darkroom using large-format multi-aperture cameras that I've built, in which the sizes and positions of the pinholes on a metal plate match the actual pattern of stars. My early source materials for these star patterns, spiral galaxies, globular clusters, and constellations were often deep-space images taken with the Hubble telescope. Each exposure via these multi-aperture cameras uses only one light source, whether a light bulb, candle, or television set: but through

the properties of light and the pinhole, a galaxy of images results. *Self Portrait as a Globular Cluster* was made by photographing a clip of myself from a taped TV show where I am discussing my Galaxy images. *The Milky Way by Candlelight* interprets the source of heavenly bodies as humble candle flames. At first glance these images appear to be just another grouping of outer space telescope images, but upon closer inspection one realizes one is looking at familiar, everyday objects—images for a new folk cosmology mythologizing the nature of light itself.

My recent installation work invites viewers to enter multi-aperture pinhole cameras. In 2015 I was invited, along with artists and scholars with a keen interest in the camera obscura in contemporary art practice, to participate as an artist collaborator in the Midnight Sun Camera Obscura Festival in Dawson City. I installed a multi-aperture pinhole tent, which developed techniques from an earlier work (*Garden Shed Galactica*, shown at Museum London, Ontario, in 2007). The multi-apertured "prospector's tent" reflected Dawson's location and historical past, and combined science, history, and art. Apertures mirroring the placement of actual stars projected images of the sun and surrounding landscape inside the tent to create an interior starry night sky that would not normally be visible during the period of the midnight sun in Dawson. In a more recent work called *Star Shed*, installed outside the McMaster Museum of Art in Hamilton, Ontario (2018), each aperture in the darkened shed projected a unique view of the exterior, creating a kaleidoscope of images. The pattern mimics that of the stars in the southern skies at this location and time of year, invisible during daylight.

The excitement, for me, lies not in photographing and reproducing something I can see, but in revealing the imperceptible (and maybe only the imagined) using the physics of light and time.

Page 140, clockwise from top left:

See the Stars, customized black vinyl-wall tent, wooden table, pinhole projection viewing frames. Midnight Sun Camera Obscura Festival, Dawson City, Yukon, June 17-21, 2015.

See the Stars, Interior view, Solstice, Dawson City Yukon, June 21, 2015.

Star Shed is a multi-aperture camera obscura chamber. Modified 6 x 5 ft steel storage shed, lenses and rear projection scrim. Installed outside McMaster Museum of Art as part of the Midnight Sun Camera Obscura Project, Hamilton, Ontario, 2018.

Star Field with Dark Matter, gelatin silver print, 14 x 11 inches, 2001.

galaxy series 145

Left: *Hand and Candle light Galaxy field*, gelatin silver print, 14 x 11 inches, 2001. Right: *E=MC2 as Whirlpool Galaxy M51*, gelatin silver print, 14 x 11 inches, 2001.

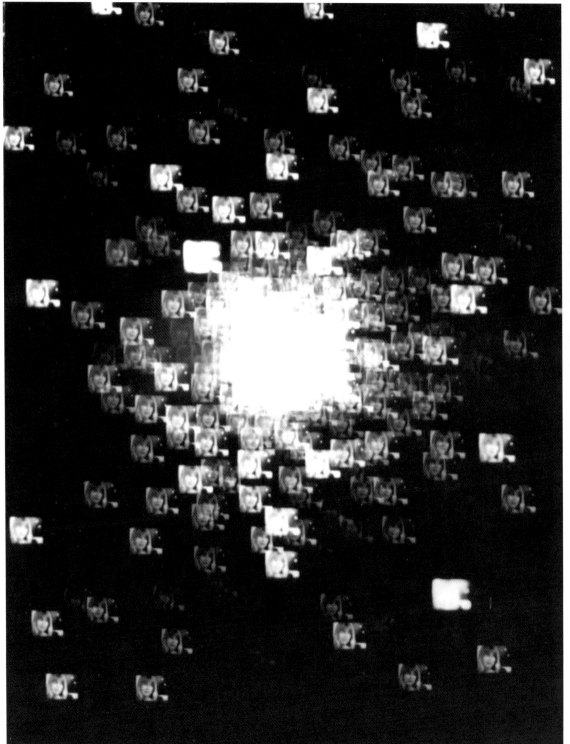

Left: *Self Portrait as a Globular Cluster*, gelatin silver print, 14 x 11 inches, 2001. Right: *Milky Way by Candle Light*, gelatin silver print, 14 x 11 inches, 1999.

Star Shed, Interior projection view, McMaster Museum of Art, Summer 2018.

150 mythologies of outer space

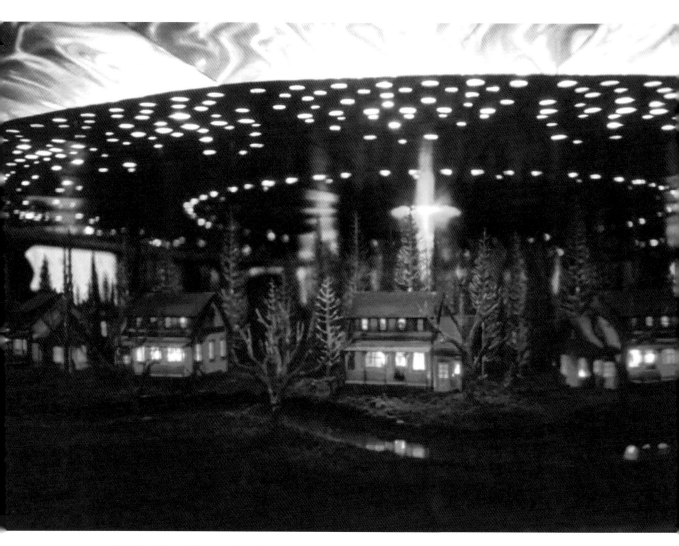

D. Hoffos, *You Will Remember When You Need to Know*, 1995, 3-channel 16 mm film, video, audio and mixed media installation, detail of miniature diorama, collection of Art Gallery of Alberta, Photo: D. Hoffos.

Next page: D. Hoffos, *Scenes from the House Dream: Circle Street*, 2003, 3-channel video, audio and mixed media installation, detail of miniature diorama, collection of the artist, Photo: David Miller & Petra Mala Miller.

nancy tousley

david hoffos:
on outer & inner space

The imaginative exploration of outer space is an ancient quest. Is it possible that Earth is the only planet in the universe with life on board? Are we really alone? The more we know, it seems, the longer the reality of outer space remains a limitless screen upon which to project our humanness, curiosity, imaginings, anxieties, and fears. The existence of extraterrestrials remains unverified, but speculative fictions about them flourish in popular culture and appear in contemporary art as well. What is it that we want from them? Where in the universe are they?

The premise of *You Will Remember When You Need to Know* (1995), a mixed-media installation work by David Hoffos, is that "They're here." With these ominous words, Carol-Anne Freeling announces the presence of malevolent spirits in *Poltergeist* (1982), a popular film based on a story by Steven Spielberg, who co-wrote the script. The plot revolves around Carol Anne, a five-year-old who talks to spectral creatures hidden deep inside the white noise on her suburban family's television set. The terrifying ghosts abduct the child by pulling her into another world through a portal concealed at the back of her bedroom closet. In the Hoffos installation, which owes something to Spielberg and to George Lucas, the spectator is plunged into another world by walking through a pair of velvet curtains. On the other side of this portal lies the dark, tension-filled scene of an alien abduction.

Hoffos, who is based in Lethbridge, Alberta, and whose work is steeped in the formal language of film, has been fascinated by outer space since childhood. Their first memory is of being in the kitchen with their family watching live television as the American astronauts Neil Armstrong and Buzz Aldrin walked on the Moon for the first time.[1] The Apollo 11 moonwalk took place in 1969; the artist was then a rapt four-year-old in a high chair. But the memory has grown stronger, Hoffos says, with the visual reinforcements that childhood memories gather over time, and it has exerted an influence on their work. For the past thirty years, Hoffos has created moving images on glowing screens set into architectural spaces that convey a sense of wonder, mystery, and dread.

You Will Remember When You Need to Know, whose title is taken from an abduction account (Mack 1994, 51), is an installation work made in two parts, each of which offers a different point of view. I experienced the work when it was exhibited for the first time, at Stride Gallery in Calgary, in 1995. In this iteration of the installation, the two parts were seen one before the other.[2] A curtained doorway opened onto an intimate space, a wood-panelled rec room, containing, on one side, a model diorama in a mirror box. The spectator looked down and into its screen-like window from what filmmakers call a God's-eye view. This high-angle viewpoint suggests that someone is watching. The spectator is thus put in the position of an alien visitor who surveys a circle of identical houses from above and at a distance. As if on the edge of a development, the glowing houses are set among trees along the bank of a creek. Night has fallen. Each house is lit up in the darkness by a blazing red fire that rages inside it. Above the burning village cum subdivision an alien mothership hovers, blocking out the sky and emitting radiant swirls of multicoloured light above, searching rays of green below. The vivid *mise en scène* is utterly still and utterly silent: an intense vision of imagined destruction frozen in a moment extended in time.

A second set of curtains gave entry to a larger space that, with a change of scale, plunged the spectator into the night air in front of two eerily glowing houses, the miniature world of the model now writ large. In the darkness, illuminated only by the lighted portals and searching rays of the mothership, the thrill of fear blossoms. A dog barks in the distance, the sound of it mixed in with the rapid, rhymical clackety-clack of a running 16-millimetre film projector, the whistling-rumbling hum of the spaceship, the trickling water in the creek, and a haunting low Gregorian chant. The scene's visual and auditory aura hangs upon a heightened moment of suspense, like a held breath, whose duration is drawn out far beyond a breath's capacity to hold. The spectator stands still in anticipation: What happens next?

D. Hoffos, *Scenes from the House Dream: Airport Hotel*, 2004, 3-channel video, audio and mixed media installation, detail of miniature diorama, collection of Nickle Galleries. Photo: D. Hoffos.

158 mythologies of outer space

Previous page: D. Hoffos, *Scenes from the House Dream: Irwin Allen*, 2005, 3-channel video, audio and mixed media installation, detail of miniature diorama, collection of the artist, Photo: David Miller & Petra Mala Miller.

Above: D. Hoffos, *Scenes from the House Dream: Winter Kitchen*, 2007, 2-channel video, audio and mixed media installation, detail of miniature diorama, collection of the artist, Photo: David Miller & Petra Mala Miller.

An alien abduction might just have taken place or yet be on the brink. The spectator's tingling spine and shivery skin, involuntary physical and psychological responses to the uncanny, ground her in the moment. As her eyes become more accustomed to the dark, curiosity draws her closer to the large 3-D pop-up reconstruction of the model's trees and houses. Through the window of one house she sees a television set in the living room. The moving image on its screen is a controversial 59.5-second film purportedly made of a female sasquatch in 1967 by Roger Patterson and Bob Gimlin (Buhs 2009, 139). As the sasquatch walks along a creek away from the intruders, the legendary beast turns her head to look back, into the camera, directly at you.

Hoffos's means of accomplishing the illusion of a life-sized storyworld are as important as the scene. The two parts of *You Will Remember When You Need to Know* are analogous to a film set and a film scene, with special effects that are synonymous with pre-cinematic illusions, made with a DIY aesthetic that originated in the punk rock movement of the 1970s. The projection on the cut-out pop-up illusion was filmed on the model, whose houses and trees are miniature HO-scale railway models. The mothership is a perforated tin disc, with a swinging lightbulb mounted above it, a nod to Ed Wood, the 1950s film director whose flying saucers were undisguised paper plates. The ingenious workings of Hoffos's vivid illusions are not concealed, but rather than diminished, the power of the illusions to delight, transfix, and frighten is enhanced by their transparency.

If the miniature film set of *You Will Remember When You Need to Know* attracts a disembodied eye, the oneiric projected scene returns the spectator to her body, turning her into an embodied viewer who is drawn into the scene. It's as if she has physically crossed a line into the liminal space of the storyworld. The 3-D pop-up has been constructed with a forced perspective, which makes it appear larger and closer to the spectator. It might be across the street. Hoffos never shows us the aliens or the landscapes of planets in outer space, as Georges Méliès did in the first science fiction film, *A Trip to the Moon* (1902). Like Spielberg, whose *Close Encounters of the Third Kind* (1977) and *E. T. the Extra-Terrestrial* (1982) were set in suburbia, Hoffos keeps us in a familiar neighbourhood.[3] Nonetheless, an uncanny alien presence is felt in the dark. It is a trick of the mind: show the spectator a glowing apparition in the dark in a gallery filled with sounds that deepen the nighttime space of its modest dimensions and this is bound to happen. Every science fiction television serial or science fiction movie the spectator has seen has prepared her for the experience.

166 mythologies of outer space

Previous page: D. Hoffos, *Scenes from the House Dream: Airstreams*, 2003, 2-channel video, audio and mixed media installation, detail of miniature diorama, private collection/lost/destroyed, Photo: D. Hoffos.

Above: D. Hoffos, *Scenes from the House Dream: Mary-Anne Sitting*, 2005, single channel video and mixed media installation, detail of false wall and cut-out/projection, collection of the artist, Photo: Joe Kelly.

us in *The Poetics of Space* (1994, 33) that "Great images have both a history and a prehistory; they are always a blend of memory and legend, with the result that we never experience an image directly. Indeed, every great image has an oneiric depth to which the personal past adds special color."

If fascination with outer space and alien presence has spawned a popular genre of literature, film, and television with a deep history, Hoffos has made it a personal medium of introspection. *Scenes from the House Dream* sends the spectator on an archetypal journey into the dark with stops at stations along the way—the twenty scenes of the illuminated dioramas—in which tiny moving figures made of light animate miniature sets. The dream world in which they move is unsettled by states of anxiety, depression, loneliness, and fear; the atmosphere is more Hitchcock and David Lynch than Spielberg and Lucas. Places of refuge and security, the rooms of a house are discovered among nocturnal exterior scenes whose locations are on suburban streets, in deep woods, at the edge of an oceanic void, in a sinister boathouse, in an airport hotel, on a train without wheels or tracks stranded in the woods, and in an art gallery where a theft is underway.

A spaceship parked on the edge of a valley overlooks a sparkling spaceport where other ships take off and land in *Irwin Allen* (2005). The scene-within-a-scene is an homage to the TV producer of 1960s science fiction TV series, such as *Voyage to the Bottom of the Sea* (1964–8) and *Lost in Space* (1965–8), who became known in the 1970s as master of the disaster genre for films such as *The Poseidon Adventure* (1972) and *The Towering Inferno* (1974). *Sherwood Schwartz* (2005), named for the producer of *The Brady Bunch*, finds a hidden alien in the happy family's living room. Meanwhile *Treehouse* (2007) represents a space of refuge and reverie, in which Hoffos, the artist in their studio whose dreams have inspired these scenes, is the occupant.

Hoffos describes the little figures in the dioramic scenes as "people alone at night in a complicated world trying to figure out their surroundings," in which danger might be lying in wait.[6] The spectator in the corridor finds herself in a similarly vulnerable position. What appears to be another spectator a little farther ahead, who is jotting notes on a pad and turns to look at her, is not a fellow human being. This sudden apprehension of a doppelganger, face to face in her own space, is literally hair-raising. The fact that in a few minutes she realizes the alien presence is a video image projected onto a life-sized plywood cut-out, entitled *Carolina* (2003), hardly lessens the powerful feeling of the uncanny that the encounter arouses. In another part of the corridor *Mary-Anne* (2005) waits, sitting on the floor with her legs outstretched, impatiently wagging her foot. The uncanny, a close relation of cognitive estrangement, is here in full play.

Freud defines the uncanny as a "remote province of aesthetics," a "class of the terrifying" that arises from two sets of contradictory ideas: the *heimlich*, or familiar and congenial, and the *unheimlich*, or concealed and kept out of sight, which is secret and dangerous.[7] The latter is the province of science fiction: the aliens who walk among us masquerading as *us*. The uncanny arises again in *Scenes from the House Dream*, with a shock, when the spectator looks into the diorama, *Petite Princess* (2008), and down a long hallway to a dining room where she sees herself as a tiny figure peering inside through a window. As she sees herself outside of herself, she suddenly becomes an actor in both spheres of the work: the waking-dream space of the corridor and the space of the individual dream scene.

The line between illusion and reality in *Scenes from the House Dream* is a permeable boundary through which people and phantasms pass, as it was in *You Will Remember When You Need to Know*. This is the crux of Hoffos's illusions. They hold out the possibility of agency. Immersed and enthralled, the spectator can surrender to illusion or, conversely, seek to understand it as a construction that tricks and distracts. Hoffos's works construct their spectator as an upright mobile individual who is free to choose a path through their spaces as an embodied viewer who is alert to what is going on around her. Unlike consumers who succumb to the phantasms of increasingly sophisticated high-tech media, the Hoffos spectator is an engaged spectator who is not allowed to disengage or to become inured to what is psychologically unbearable. In a complex contemporary world the ability to separate reality and fantasy becomes an increasingly necessary skill. According to the science fiction writer Octavia E. Butler, "We're on our own, the focus of no interest except our consuming interest in ourselves. . . . How strange: In our ongoing eagerness to create aliens, we express our need for them. . . . And yet we are unable to get along with those aliens closest to us, those aliens who are, of course, ourselves. . . . Sometimes we just need someone to talk to—someone we can trust to listen and care."[8] History tells us to be careful when we make the choice.

D. Hoffos, *Scenes from the House Dream: Carolina* and *Absinthe Bar*, 2003 and 2004, 2- channel video, audio and mixed media installations, detail of cut-outs/projections, collections of Art Gallery of Nova Scotia and the artist. Photo: Joe Kelly.

notes

1. The televised footage of the Apollo 11 moon walk can be viewed online at https://www.youtube.com/watch?v=S9HdPi9Ikhk. Accessed 24 August 2023. Millions of people watching worldwide witnessed the momentous event. Dread associated with watching the live broadcast arose from the anticipation that something could go wrong.

2. The first iteration of *You Will Remember When You Need to Know* was shown only in Calgary at Stride Gallery, in 1995. Hoffos made a second iteration of the installation, which toured to London, Ontario, and Lisbon, Portugal, in 1999, with a smaller pop-up illusion and the addition of a video projection of a figure onto a life-sized cut-out. Its configurations were variable. The second iteration is in the collection of the Art Gallery of Alberta, with a cut-out projection made specifically for the gallery.

3. Stephen Spielberg directed or wrote a trio of science fiction films set in a richly textured American suburbia: *Close Encounters of the Third Kind* (1977), *Poltergeist* (1982), which was directed by Tobe Hooper, and *E. T. the Extra-Terrestrial* (1982). Spielberg and George Lucas films were important influences on Hoffos's work at this early stage of his career. Spielberg mirrored Hoffos's experience of suburbia. The Hoffos family lived in the Calgary suburb of Lake Bonavista, the first community in Canada built around a man-made lake, during his adolescence.

4. Between 2003 and 2008, *Scenes from the House Dream* was shown in sections at the artist's then dealer, TrepanierBaer Gallery, in Calgary, Alberta. The complete installation toured from 2008 to 2011 in an exhibition organized by Rodman Hall Art Centre, Brock University, in partnership with the Southern Alberta Art Gallery, to five venues, including the National Gallery of Canada and the Illingworth Kerr Gallery, Alberta College of Art and Design (now the Alberta University for the Arts).

5. The most recent scholarly edition is that of Rosen 1967. The introduction lays out the circumstances of the work's publication. See also the Somnium Project, available online at https://somniumproject.wordpress.com.

6. Interview with the author, August 17, 2023.

7. Sigmund Freud, "The 'Uncanny'" (1919), translated by Alix Strachey, Massachusetts Institute of Technology, accessed August 5, 2023, https://web.mit.edu/allanmc/www/freud1.pdf.

8. Octavia Butler, "The Monophobic Response," Connie Samaras, accessed August 3, 2023, https://www.conniesamaras.com/DOCs_current/Web_Biblio_pdfs.5.11/26_Biblio_Butler_partialcorr.pdf.

bibliography

Bachelard, Gaston. 1994. *The Poetics of Space*. Boston: Beacon Press. First published in French under the title *La poétique de l'espace* in 1958.

Braudy, Leo. 1999. "Film Genres." In *Film Theory and Criticism: Introductory Readings*, 5th ed., edited by Leo Braudy and Marshall Cohen, 607–724. New York: Oxford University Press.

Buhs, Joshua Blu. 2009. *Bigfoot: The Life and Times of a Legend*. Chicago: Chicago University Press.

Farah, Stephen. 2014. "Jung's dream house and discovering your own archetypal home," Centre of Applied Jungian Studies https://appliedjung.com/jungs-dream-house/, accessed August 2023.

Mack, J. E. 1994. *Abduction: Human Encounters with Aliens*. New York: Charles Scribner's Sons.

Rosen, Edward, trans. and commentary. 1967 *Kepler's Somnium. The Dream, or Posthumous Work on Lunar Astronomy*. Madison: University of Wisconsin Press.

Suvin, Darko. 2017. "On the Poetics of the Science Fiction Genre." In *Science Fiction Criticism: An Anthology of Essential Writings*, edited by Rob Latham, 116–20. London: Bloomsbury Academic.

Warner, Marina. 2006. *Phantasmagoria: Spirit Visions, Metaphors, and Media into the Twenty-First Century*. Oxford: Oxford University Press.

m. n. hutchinson

the book of the damned

Charles Fort wrote in the early twentieth century an accounting of meteorological events and fanciful theories and expounded on them in a collection titled *The Book of the Damned* (1999). He may have been called the father of all crackpots, but he used these alternative theories to point out the absurdities in then current mainstream scientific explanations about anomalous meteorological phenomena. The book can be read for both the first-hand accounts and the critique of contemporary scientific research, or more properly the lack of it, when confronted with confounding human experience. Fort was an avid collector of testimonials about rare and odd occurrences of objects that fall from the sky, and I have quoted twelve of them on text panels in the piece. Tongue planted firmly in cheek, he supposed the existence of extraterrestrial visitation decades before man's first heavier-than-air flight. The "damned" in this instance is the evidence that the scientific community would prefer to ignore, and as many of the testimonials do indeed reveal themselves to be errors of perception, Fort recognizes that the explanations we seek may reside in "our slippery brains."

The images from *The Book of the Damned* are loosely derived from a close reading of the history of Western philosophy. They focus on twenty-eight moments from that history that I felt needed embodying, with titles like *Logos*, *The Suspicions of St. Augustine*, *Res Externa*, or *He Started Practising His Alien Face*. I shot them using ultra-rare infrared four-by-five-inch sheet film, which necessitated several creative tricks to hold focus and achieve the desired composition. This project also marks an end to a two-decade project of self-portraiture, just in time for selfie culture to take over, with the difference being that technical constraints required a much more rigorous construction of the image than is promulgated by the simple cellphone camera.

Each photograph is mounted between a sandwich of aluminum, felt, and Plexiglass that creates a Reichian Orgone Accumulator, which supposedly concentrates and stores free-ranging orgasmic energy when packed in their specially designed wooden crates. Wilhelm Reich was a Viennese psychoanalyst who trained with Freud and became convinced that orgone energy stored in the accumulator could cure cancer and bring rain. Censured and imprisoned by the US government, he was a substantial crackpot.

I'm reminded that, unlike the present climate of noxious widespread conspiracy theories that are surely originated by non-believers with the intent to deceive, Fort said he didn't believe anything he wrote and didn't expect anyone else to either. While there is evidence that Reich really did believe in what he proposed, he at least had the background and training for the more credible to entertain his ideas.

My original proposal for this work was an attempt to bring about some critical views on theorizing in general. These critiques reside mainly in the domain of human bias, and while bias is present in everyone, it often presents itself in a dogmatic adherence to a traditional or established belief system. Fort pointed out that this dogmatism was as prevalent in the scientific community as it was in everyday life, and that this community encapsulates a system that requires faith when comprehension is hard to come by in a complex world. This faith works in opposition to a true scientific method and thus creates a bias that leads to anomalous eyewitness accounts being discounted out of hand. *The Book of the Damned* merely pointed this out.

As always, damn the anomalies.

174 mythologies of outer space

the book of the damned 175

robert thirsk

afterword

I have enjoyed a privileged career as an astronaut. Living and working in space for over two hundred days aboard three different spacecraft was the fulfillment of a childhood dream. My career did not entail solely the exploration of space, but also the exploration of oneself. The demands of the flights, as well as the rigours of training, regularly took me to my limits—physically, mentally, and emotionally. I enjoyed every minute of it.

I am, therefore, pleased that the Calgary Institute for the Humanities also deems the exploration of outer space to be a socially important issue and worthy of interdisciplinary discussion. In fact, during a daylong community forum in May 2022, the Institute convened esteemed scholars and citizens to celebrate and deliberate on a range of topics related to the final frontier. How gratifying!

And what an eclectic group of humanists, artists, and social scientists that gathered together! The contributors to the forum entitled *The Final Frontier: Mythologies of Outer Space* included, among others, a space archaeologist, an Indigenous astronomer, science fiction scholars, poets, and artists. Some contributors shared their love of astronomy and others their fascination with space flight. In this publication, which expands upon the forum deliberations, I have enjoyed reading how the ancient Greeks regarded space, and how more contemporary writers have imagined voyages to the Moon. I share the same sense of wonder and spirit of adventure.

Image courtesy of NASA. https://unsplash.com/@nasa

Of all human endeavours, space exploration must surely be one of the most all-encompassing. Everything that I have accomplished in my career as an astronaut has been based on collaboration—collaboration across disciplines, across cultures, and across international borders. While my own space travels were confined to low Earth orbit, I await upcoming explorations farther into our solar system by the next generation of astronauts. A return to the Moon is anticipated later this decade (*Global Exploration Roadmap* 2018). I hope to see astronauts walk on Mars within my lifetime.

My ongoing engagement in human space flight has often led me into lively debates on exploration with colleagues in a variety of settings—aboard orbiting spacecraft, as panelists at conferences, or over beverages at a neighbourhood pub. Being an engineer, physician, and astronaut, I tend to contribute technical, medical, and operational perspectives to these conversations. My colleagues add insights from their own particular backgrounds and experiences.

Participation from the humanities, the arts, and the social sciences in these sorts of discussions is especially valued. I admire my liberal arts colleagues for their abilities to ask the right questions and to examine technological matters through a lens of humanity. Positioning problems of societal importance within the context of a bigger picture and in relation to comparable events from the past is critical to addressing the complex, multi-faceted issues facing today's space program.

bibliography

Argenti, Marco. 2024. "Why Engineers Should Study Philosophy." *Harvard Business Review*, April 16, 2024. https://hbr.org/2024/04/why-engineers-should-study-philosophy.

Brown, Craig, and Matthew Alabaster. 2023. *Expanding Frontiers: The Down to Earth Guide to Investing in Space*. London: PwC Strategy& and UK Space Agency. https://www.strategyand.pwc.com/uk/en/reports/expanding-frontiers-down-to-earth-guide-to-investing-in-space.pdf.

Byers, Michael, and Aaron Boley. 2023. *Who Owns Outer Space? International Law, Astrophysics, and the Sustainable Development of Space*. Cambridge: Cambridge University Press. https://doi.org/10.1017/9781108597135.

Fulgham, Robert. 1988. *All I Really Need to Know I Learned in Kindergarten: Uncommon Thoughts on Common Things*. New York: Ivy.

The Global Exploration Roadmap. 2018. NP-2018-01-2502-HQ. Washington, DC: National Aeronautics and Space Administration Headquarters. https://www.nasa.gov/wp content/uploads/2015/01/ger_2018_small_mobile.pdf?emrc=4abb2f.

Green, Jessica F. 2022. "The Final Frontier Soon May No Longer Belong to All of Us." *New York Times*, July 28, 2022. https://www.nytimes.com/2022/07/28/opinion/russia-us-outer-space.html.

Hardin, Garrett. 1968. "The Tragedy of the Commons." *Science* 162: 1243–8.

Husbands Fealing, Kaye, Aubrey DeVeny Incorvaia, and Richard Utz. 2002. "Humanizing Science and Engineering for the Twenty-First Century." *Issues in Science and Technology* 39 (1). https://issues.org/humanizing-science-engineering-husbands-fealing-incorvaia-utz/.

Kennedy, John F. 1962. "Address at Rice University, Houston, Texas, 12 September 1962." John F. Kennedy Presidential Library and Museum (JFKPOF-040-001). https://www.jfklibrary.org/asset-viewer/archives/jfkpof-040-001#?image_identifier=JFKPOF-040-001-p0001.

Mahroum, Sami, and Rashid Ansari. 2018. "The Few Humanities Majors Who Dominate in the Business World." *The Conversation*, August 27, 2018. https://theconversation.com/the-few-humanities-majors-who-dominate-in-the-business-world-100999.

Outer Space Treaty. 1967. United Nations General Assembly Resolution 2222 (XXI). United Nations Office for Outer Space Affairs. https://www.unoosa.org/pdf/gares/ARES_21_2222E.pdf.

Samson, Victoria, and Seth Walton. 2024. "FAQ: What we Know about Russia's Alleged Nuclear Anti-satellite Weapon." *Secure World Foundation*, April 14, 2024. https://swfound.org/media/207844/swf_vs_sw_russiannuclearasat.pdf.

Stonechild, Blair. 2024. "Humanity's Survival Depends on Listening to Indigenous Voices." *Globe and Mail*, January 27, 2024.

UN moon treaty 34/68
agreement governing the activities of states on the moon & other celestial bodies ▶

Conference on the Exploration and Peaceful Uses of Outer Space and to designate the Committee on the Peaceful Uses of Outer Space as the Preparatory Committee for the Conference,

Having considered the part of the report of the Committee on the Peaceful Uses of Outer Space[23] concerning its work in its capacity as Preparatory Committee for the Second United Nations Conference on the Exploration and Peaceful Uses of Outer Space,

Noting with satisfaction that the Committee, in its capacity as Preparatory Committee for the Conference, has submitted detailed recommendations on the preparation and organization of the Conference,

1. *Endorses* the detailed recommendations submitted in paragraphs 84 to 115 of its report[23] by the Committee on the Peaceful Uses of Outer Space in its capacity as Preparatory Committee for the Second United Nations Conference on the Exploration and Peaceful Uses of Outer Space;

2. *Adopts* the provisional agenda for the Conference as set out in paragraph 99 of the report of the Committee;

3. *Endorses* in particular:

(*a*) The recommendation of the Committee that the Second United Nations Conference on the Exploration and Peaceful Uses of Outer Space should be held in the latter half of 1982;

(*b*) The recommendations of the Committee concerning the preparation and organization of the Conference, including the secretariat, bureau and form of the Conference;

(*c*) The recommendation of the Committee on the ceiling for the cost of the Conference;

4. *Requests* the Committee to submit to the General Assembly at its thirty-fifth session a recommendation on the venue of the Conference;

5. *Requests* the Committee to continue with its preparatory work for the Conference;

6. *Requests* the Secretary-General to make, within the ceiling for expenditure established for the Conference, the necessary organizational and administrative arrangements, as set out in the relevant paragraphs of the report of the Committee.

89th plenary meeting
5 December 1979

34/68. Agreement Governing the Activities of States on the Moon and Other Celestial Bodies

The General Assembly,

Reaffirming the importance of international co-operation in the field of the exploration and peaceful uses of outer space, including the moon and other celestial bodies, and of promoting the rule of law in this field of human endeavour,

Recalling its resolution 2779 (XXVI) of 29 November 1971, in which it requested the Committee on the Peaceful Uses of Outer Space and its Legal Sub-Committee to consider the question of the elaboration of a draft international treaty concerning the moon, as well as its resolutions 2915 (XXVII) of 9 November 1972, 3182 (XXVIII) of 18 December 1973, 3234 (XXIX) of 12 November 1974, 3388 (XXX) of 18 November 1975, 31/8 of 8 November 1976, 32/196 A of 20 December 1977 and 33/16 of 10 November 1978, in which it, *inter alia*, encouraged the elaboration of the draft treaty relating to the moon,

Recalling, in particular, that in resolution 33/16 it endorsed the recommendation of the Committee on the Peaceful Uses of Outer Space that the Legal Sub-Committee at its eighteenth session should continue as a matter of priority its efforts to complete the draft treaty relating to the moon,

Having considered the relevant part of the report of the Committee on the Peaceful Uses of Outer Space,[24] in particular paragraphs 62, 63 and 65,

Noting with satisfaction that the Committee on the Peaceful Uses of Outer Space, on the basis of the deliberations and recommendations of the Legal Sub-Committee, has completed the text of the draft Agreement Governing the Activities of States on the Moon and Other Celestial Bodies,

Having considered the text of the draft Agreement Governing the Activities of States on the Moon and Other Celestial Bodies,[25]

1. *Commends* the Agreement Governing the Activities of States on the Moon and Other Celestial Bodies, the text of which is annexed to the present resolution;

2. *Requests* the Secretary-General to open the Agreement for signature and ratification at the earliest possible date;

3. *Expresses its hope* for the widest possible adherence to this Agreement.

89th plenary meeting
5 December 1979

ANNEX

Agreement Governing the Activities of States on the Moon and Other Celestial Bodies

The States Parties to this Agreement,

Noting the achievements of States in the exploration and use of the moon and other celestial bodies,

Recognizing that the moon, as a natural satellite of the earth, has an important role to play in the exploration of outer space,

Determined to promote on the basis of equality the further development of co-operation among States in the exploration and use of the moon and other celestial bodies,

Desiring to prevent the moon from becoming an area of international conflict,

Bearing in mind the benefits which may be derived from the exploitation of the natural resources of the moon and other celestial bodies,

Recalling the Treaty on Principles Governing the Activities of States in the Exploration and Use of Outer Space, including the Moon and Other Celestial Bodies,[26] the Agreement on the Rescue of Astronauts, the Return of Astronauts and the Return of Objects Launched into Outer Space,[27] the Convention on International Liability for Damage Caused by Space Objects,[28] and the Convention on Registration of Objects Launched into Outer Space,[29]

Taking into account the need to define and develop the provisions of these international instruments in relation to the moon and other celestial bodies, having regard to further progress in the exploration and use of outer space,

Have agreed on the following:

[23] *Official Records of the General Assembly, Thirty-fourth Session, Supplement No. 20* (A/34/20), sect. II.C.
[24] *Ibid.*, sect. II.A.7.
[25] *Ibid., Supplement No. 20* (A/34/20), annex II.
[26] Resolution 2222 (XXI), annex.
[27] Resolution 2345 (XXII), annex.
[28] Resolution 2777 (XXVI), annex.
[29] Resolution 3235 (XXIX), annex.

Article 1

1. The provisions of this Agreement relating to the moon shall also apply to other celestial bodies within the solar system, other than the earth, except in so far as specific legal norms enter into force with respect to any of these celestial bodies.

2. For the purposes of this Agreement reference to the moon shall include orbits around or other trajectories to or around it.

3. This Agreement does not apply to extraterrestrial materials which reach the surface of the earth by natural means.

Article 2

All activities on the moon, including its exploration and use, shall be carried out in accordance with international law, in particular the Charter of the United Nations, and taking into account the Declaration on Principles of International Law concerning Friendly Relations and Co-operation among States in accordance with the Charter of the United Nations,[30] adopted by the General Assembly on 24 October 1970, in the interest of maintaining international peace and security and promoting international co-operation and mutual understanding, and with due regard to the corresponding interests of all other States Parties.

Article 3

1. The moon shall be used by all States Parties exclusively for peaceful purposes.

2. Any threat or use of force or any other hostile act or threat of hostile act on the moon is prohibited. It is likewise prohibited to use the moon in order to commit any such act or to engage in any such threat in relation to the earth, the moon, spacecraft, the personnel of spacecraft or man-made space objects.

3. States Parties shall not place in orbit around or other trajectory to or around the moon objects carrying nuclear weapons or any other kinds of weapons of mass destruction or place or use such weapons on or in the moon.

4. The establishment of military bases, installations and fortifications, the testing of any type of weapons and the conduct of military manoeuvres on the moon shall be forbidden. The use of military personnel for scientific research or for any other peaceful purposes shall not be prohibited. The use of any equipment or facility necessary for peaceful exploration and use of the moon shall also not be prohibited.

Article 4

1. The exploration and use of the moon shall be the province of all mankind and shall be carried out for the benefit and in the interests of all countries, irrespective of their degree of economic or scientific development. Due regard shall be paid to the interests of present and future generations as well as to the need to promote higher standards of living and conditions of economic and social progress and development in accordance with the Charter of the United Nations.

2. States Parties shall be guided by the principle of co-operation and mutual assistance in all their activities concerning the exploration and use of the moon. International co-operation in pursuance of this Agreement should be as wide as possible and may take place on a multilateral basis, on a bilateral basis or through international intergovernmental organizations.

Article 5

1. States Parties shall inform the Secretary-General of the United Nations as well as the public and the international scientific community, to the greatest extent feasible and practicable, of their activities concerned with the exploration and use of the moon. Information on the time, purposes, locations, orbital parameters and duration shall be given in respect of each mission to the moon as soon as possible after launching, while information on the results of each mission, including scientific results, shall be furnished upon completion of the mission. In the case of a mission lasting more than sixty days, information on conduct of the mission, including any scientific results, shall be given periodically, at thirty-day intervals. For missions lasting more than six months, only significant additions to such information need be reported thereafter.

2. If a State Party becomes aware that another State Party plans to operate simultaneously in the same area of or in the same orbit around or trajectory to or around the moon, it shall promptly inform the other State of the timing of and plans for its own operations.

3. In carrying out activities under this Agreement, States Parties shall promptly inform the Secretary-General, as well as the public and the international scientific community, of any phenomena they discover in outer space, including the moon, which could endanger human life or health, as well as of any indication of organic life.

Article 6

1. There shall be freedom of scientific investigation on the moon by all States Parties without discrimination of any kind, on the basis of equality and in accordance with international law.

2. In carrying out scientific investigations and in furtherance of the provisions of this Agreement, the States Parties shall have the right to collect on and remove from the moon samples of its mineral and other substances. Such samples shall remain at the disposal of those States Parties which caused them to be collected and may be used by them for scientific purposes. States Parties shall have regard to the desirability of making a portion of such samples available to other interested States Parties and the international scientific community for scientific investigation. States Parties may in the course of scientific investigations also use mineral and other substances of the moon in quantities appropriate for the support of their missions.

3. States Parties agree on the desirability of exchanging scientific and other personnel on expeditions to or installations on the moon to the greatest extent feasible and practicable.

Article 7

1. In exploring and using the moon, States Parties shall take measures to prevent the disruption of the existing balance of its environment, whether by introducing adverse changes in that environment, by its harmful contamination through the introduction of extra-environmental matter or otherwise. States Parties shall also take measures to avoid harmfully affecting the environment of the earth through the introduction of extraterrestrial matter or otherwise.

2. States Parties shall inform the Secretary-General of the United Nations of the measures being adopted by them in accordance with paragraph 1 of this article and shall also, to the maximum extent feasible, notify him in advance of all placements by them of radio-active materials on the moon and of the purposes of such placements.

3. States Parties shall report to other States Parties and to the Secretary-General concerning areas of the moon having special scientific interest in order that, without prejudice to the rights of other States Parties, consideration may be given to the designation of such areas as international scientific preserves for which special protective arrangements are to be agreed upon in consultation with the competent bodies of the United Nations.

Article 8

1. States Parties may pursue their activities in the exploration and use of the moon anywhere on or below its surface, subject to the provisions of this Agreement.

2. For these purposes States Parties may, in particular:

(a) Land their space objects on the moon and launch them from the moon;

(b) Place their personnel, space vehicles, equipment, facilities, stations and installations anywhere on or below the surface of the moon.

Personnel, space vehicles, equipment, facilities, stations and installations may move or be moved freely over or below the surface of the moon.

3. Activities of States Parties in accordance with paragraphs 1 and 2 of this article shall not interfere with the activities of other States Parties on the moon. Where such interference may occur, the States Parties concerned shall undertake consultations in accordance with article 15, paragraphs 2 and 3, of this Agreement.

[30] Resolution 2625 (XXV), annex.

Article 9

1. States Parties may establish manned and unmanned stations on the moon. A State Party establishing a station shall use only that area which is required for the needs of the station and shall immediately inform the Secretary-General of the United Nations of the location and purposes of that station. Subsequently, at annual intervals that State shall likewise inform the Secretary-General whether the station continues in use and whether its purposes have changed.

2. Stations shall be installed in such a manner that they do not impede the free access to all areas of the moon of personnel, vehicles and equipment of other States Parties conducting activities on the moon in accordance with the provisions of this Agreement or of article I of the Treaty on Principles Governing the Activities of States in the Exploration and Use of Outer Space, including the Moon and Other Celestial Bodies.[26]

Article 10

1. States Parties shall adopt all practicable measures to safeguard the life and health of persons on the moon. For this purpose they shall regard any person on the moon as an astronaut within the meaning of article V of the Treaty on Principles Governing the Activities of States in the Exploration and Use of Outer Space, including the Moon and Other Celestial Bodies[26] and as part of the personnel of a spacecraft within the meaning of the Agreement on the Rescue of Astronauts, the Return of Astronauts and the Return of Objects Launched into Outer Space.[27]

2. States Parties shall offer shelter in their stations, installations, vehicles and other facilities to persons in distress on the moon.

Article 11

1. The moon and its natural resources are the common heritage of mankind, which finds its expression in the provisions of this Agreement, in particular in paragraph 5 of this article.

2. The moon is not subject to national appropriation by any claim of sovereignty, by means of use or occupation, or by any other means.

3. Neither the surface nor the subsurface of the moon, nor any part thereof or natural resources in place, shall become property of any State, international intergovernmental or non-governmental organization, national organization or non-governmental entity or of any natural person. The placement of personnel, space vehicles, equipment, facilities, stations and installations on or below the surface of the moon, including structures connected with its surface or subsurface, shall not create a right of ownership over the surface or the subsurface of the moon or any areas thereof. The foregoing provisions are without prejudice to the international régime referred to in paragraph 5 of this article.

4. States Parties have the right to exploration and use of the moon without discrimination of any kind, on the basis of equality and in accordance with international law and the provisions of this Agreement.

5. States Parties to this Agreement hereby undertake to establish an international régime, including appropriate procedures, to govern the exploitation of the natural resources of the moon as such exploitation is about to become feasible. This provision shall be implemented in accordance with article 18 of this Agreement.

6. In order to facilitate the establishment of the international régime referred to in paragraph 5 of this article, States Parties shall inform the Secretary-General of the United Nations as well as the public and the international scientific community, to the greatest extent feasible and practicable, of any natural resources they may discover on the moon.

7. The main purposes of the international régime to be established shall include:

 (a) The orderly and safe development of the natural resources of the moon;

 (b) The rational management of those resources;

 (c) The expansion of opportunities in the use of those resources;

 (d) An equitable sharing by all States Parties in the benefits derived from those resources, whereby the interests and needs of the developing countries, as well as the efforts of those countries which have contributed either directly or indirectly to the exploration of the moon, shall be given special consideration.

8. All the activities with respect to the natural resources of the moon shall be carried out in a manner compatible with the purposes specified in paragraph 7 of this article and the provisions of article 6, paragraph 2, of this Agreement.

Article 12

1. States Parties shall retain jurisdiction and control over their personnel, space vehicles, equipment, facilities, stations and installations on the moon. The ownership of space vehicles, equipment, facilities, stations and installations shall not be affected by their presence on the moon.

2. Vehicles, installations and equipment or their component parts found in places other than their intended location shall be dealt with in accordance with article 5 of the Agreement on the Rescue of Astronauts, the Return of Astronauts and the Return of Objects Launched into Outer Space.[27]

3. In the event of an emergency involving a threat to human life, States Parties may use the equipment, vehicles, installations, facilities or supplies of other States Parties on the moon. Prompt notification of such use shall be made to the Secretary-General of the United Nations or the State Party concerned.

Article 13

A State Party which learns of the crash landing, forced landing or other unintended landing on the moon of a space object, or its component parts, that were not launched by it, shall promptly inform the launching State Party and the Secretary-General of the United Nations.

Article 14

1. States Parties to this Agreement shall bear international responsibility for national activities on the moon, whether such activities are carried out by governmental agencies or by non-governmental entities, and for assuring that national activities are carried out in conformity with the provisions of this Agreement. States Parties shall ensure that non-governmental entities under their jurisdiction shall engage in activities on the moon only under the authority and continuing supervision of the appropriate State Party.

2. States Parties recognize that detailed arrangements concerning liability for damage caused on the moon, in addition to the provisions of the Treaty on Principles Governing the Activities of States in the Exploration and Use of Outer Space, including the Moon and Other Celestial Bodies[26] and the Convention on International Liability for Damage Caused by Space Objects,[28] may become necessary as a result of more extensive activities on the moon. Any such arrangements shall be elaborated in accordance with the procedure provided for in article 18 of this Agreement.

Article 15

1. Each State Party may assure itself that the activities of other States Parties in the exploration and use of the moon are compatible with the provisions of this Agreement. To this end, all space vehicles, equipment, facilities, stations and installations on the moon shall be open to other States Parties. Such States Parties shall give reasonable advance notice of a projected visit, in order that appropriate consultations may be held and that maximum precautions may be taken to assure safety and to avoid interference with normal operations in the facility to be visited. In pursuance of this article, any State Party may act on its own behalf or with the full or partial assistance of any other State Party or through appropriate international procedures within the framework of the United Nations and in accordance with the Charter.

2. A State Party which has reason to believe that another State Party is not fulfilling the obligations incumbent upon it pursuant to this Agreement or that another State Party is interfering with the rights which the former State has under this Agreement may request consultations with that State Party. A

State Party receiving such a request shall enter into such consultations without delay. Any other State Party which requests to do so shall be entitled to take part in the consultations. Each State Party participating in such consultations shall seek a mutually acceptable resolution of any controversy and shall bear in mind the rights and interests of all States Parties. The Secretary-General of the United Nations shall be informed of the results of the consultations and shall transmit the information received to all States Parties concerned.

3. If the consultations do not lead to a mutually acceptable settlement which has due regard for the rights and interests of all States Parties, the parties concerned shall take all measures to settle the dispute by other peaceful means of their choice appropriate to the circumstances and the nature of the dispute. If difficulties arise in connexion with the opening of consultations or if consultations do not lead to a mutually acceptable settlement, any State Party may seek the assistance of the Secretary-General, without seeking the consent of any other State Party concerned, in order to resolve the controversy. A State Party which does not maintain diplomatic relations with another State Party concerned shall participate in such consultations, at its choice, either itself or through another State Party or the Secretary-General as intermediary.

Article 16

With the exception of articles 17 to 21, references in this Agreement to States shall be deemed to apply to any international intergovernmental organization which conducts space activities if the organization declares its acceptance of the rights and obligations provided for in this Agreement and if a majority of the States members of the organization are States Parties to this Agreement and to the Treaty on Principles Governing the Activities of States in the Exploration and Use of Outer Space, including the Moon and Other Celestial Bodies.[26] States members of any such organization which are States Parties to this Agreement shall take all appropriate steps to ensure that the organization makes a declaration in accordance with the provisions of this article.

Article 17

Any State Party to this Agreement may propose amendments to the Agreement. Amendments shall enter into force for each State Party to the Agreement accepting the amendments upon their acceptance by a majority of the States Parties to the Agreement and thereafter for each remaining State Party to the Agreement on the date of acceptance by it.

Article 18

Ten years after the entry into force of this Agreement, the question of the review of the Agreement shall be included in the provisional agenda of the General Assembly of the United Nations in order to consider, in the light of past application of the Agreement, whether it requires revision. However, at any time after the Agreement has been in force for five years, the Secretary-General of the United Nations, as depository, shall, at the request of one third of the States Parties to the Agreement and with the concurrence of the majority of the States Parties, convene a conference of the States Parties to review this Agreement. A review conference shall also consider the question of the implementation of the provisions of article 11, paragraph 5, on the basis of the principle referred to in paragraph 1 of that article and taking into account in particular any relevant technological developments.

Article 19

1. This Agreement shall be open for signature by all States at United Nations Headquarters in New York.

2. This Agreement shall be subject to ratification by signatory States. Any State which does not sign this Agreement before its entry into force in accordance with paragraph 3 of this article may accede to it at any time. Instruments of ratification or accession shall be deposited with the Secretary-General of the United Nations.

3. This Agreement shall enter into force on the thirtieth day following the date of deposit of the fifth instrument of ratification.

4. For each State depositing its instrument of ratification or accession after the entry into force of this Agreement, it shall enter into force on the thirtieth day following the date of deposit of any such instrument.

5. The Secretary-General shall promptly inform all signatory and acceding States of the date of each signature, the date of deposit of each instrument of ratification or accession to this Agreement, the date of its entry into force and other notices.

Article 20

Any State Party to this Agreement may give notice of its withdrawal from the Agreement one year after its entry into force by written notification to the Secretary-General of the United Nations. Such withdrawal shall take effect one year from the date of receipt of this notification.

Article 21

The original of this Agreement, of which the Arabic, Chinese, English, French, Russian and Spanish texts are equally authentic, shall be deposited with the Secretary-General of the United Nations, who shall send certified copies thereof to all signatory and acceding States.

IN WITNESS WHEREOF the undersigned, being duly authorized thereto by their respective Governments, have signed this Agreement, opened for signature at New York on[31]

contributors

Dianne Bos has been teaching and exhibiting her photo-based work internationally for over forty years. Some of her recent exhibitions feature handmade cameras, walk-in light installations, and sound pieces. She has evolved various thematic bodies of work and merged technical innovations to create new visual hybrids: her innovative uses of pinhole, film, camera obscura, photogram, installation, and cyanotype all explore the world around us. "The excitement, for me, lies not in photographing and reproducing something I can see, but in revealing the imperceptible (and maybe only the imagined) using the physics of light and time and traditional darkroom techniques." www.diannebos.ca.

Marjan Eggermont is a professor (teaching) and associate dean sustainability in the Schulich School of Engineering, in addition to serving as the co-director for the UNU Hub at the University of Calgary, current SDSN co-chair (research), and one of the academic co-leads for Democracy, Justice, and Sustainability in the Institutes for Transdisciplinary Scholarship. She is a Biomimicry Institute fellow and has been working in the field of bio-inspired design since 2004 with a focus on visualization and abstraction. She co-founded and designs *Zygote Quarterly* (zqjournal.org), an online bio-inspired design journal, to showcase the nexus of science and design.

Jim Ellis is professor of English at the University of Calgary and director of the Calgary Institute for the Humanities, Canada's oldest humanities institute. He teaches sixteenth-century poetry and prose, about which he has written numerous essays and books, including, most recently, *The Poem, the Garden and the World: Poetry and Performativity in Elizabethan England* (Northwestern University Press, 2023). As director of the CIH, he has edited a series of books on the environmental humanities: *Calgary: City of Animals* (2017); *Water Rites: Reimagining Water in the West* (2018); and *Intertwined Histories: Plants in Their Social Contexts* (2019).

Kyle Flemmer is a writer, publisher, and digital media artist from Calgary, in Treaty 7 territory. He founded the Blasted Tree Publishing Company in 2014, and his first book, *Barcode Poetry*, was published in 2021. Kyle's first trade book of poetry, *Supergiants*, is forthcoming from Wolsak and Wynn in 2025. His most recent chapbooks include *About Me* from No Press and *Building Permit: Capitol Hill* from Gap Riot Press.

Stefania Forlini is associate professor of English at the University of Calgary, where she teaches and researches nineteenth-century literature, material culture, science, and science fiction. She recently edited the Broadview critical edition of Arthur Machen's *The Three Impostors* (1895) and has published in the areas of Victorian studies, science fiction studies, the digital humanities, and humanistic information visualization.

Alice Gorman is an internationally recognized leader in the field of space archaeology. Her research on space exploration has been featured in *National Geographic*, *New Scientist*, and *Archaeology* magazine, and her book *Dr Space Junk vs the Universe: Archaeology and the Future* (2019) won the NIB Award People's Choice and the John Mulvaney Book Award. She is a faculty member of the International Space University's Southern Hemisphere Space Program in Adelaide. She has worked extensively in Indigenous heritage management, providing advice for the mining industry, urban development, government departments, local councils, and Native Title groups in New South Wales, Western Australia, South Australia, and Queensland. She is also a specialist in stone tool analysis and the Aboriginal use of bottle glass after European settlement.

contributors

David Hoffos has maintained a multidisciplinary practice since 1992, with over forty solo exhibitions at public institutions across North America and Europe. In 2009 their sprawling, six-year installation series, *Scenes from the House Dream*, debuted at the Southern Alberta Art Gallery, Lethbridge, before a cross-country tour that included the National Gallery of Canada, Ottawa, the Art Gallery of Nova Scotia, Halifax, the Illingworth Kerr Gallery, Calgary, and the Museum of Contemporary Canadian Art, Toronto. In 2014 Hoffos completed permanent public sculpture projects in Grande Prairie and Lethbridge. They have received numerous awards, including, the Images Grand Prize, 2007, and the inaugural Sobey Art Award (second place), 2002.

Noreen Humble is professor of Classics and associate director at the Calgary Institute for the Humanities. She has written widely on the ancient Greek authors Xenophon and Plutarch, as well as on their reception from the classical world to the present day. She is the author of the award-winning *Xenophon of Athens: A Socratic on Sparta* (Cambridge University Press, 2021). She is currently engaged in a number of international collaborative projects looking at the transmission of ancient histories through the lenses of book history and translation studies.

M. N. Hutchinson has been a working photographer for over thirty years. He both runs a commercial business whose work included album covers for A&M Records and is a nationally recognized professional artist. His practice has been contrarily cross-media. He has exhibited photographs, printmaking, sculptural installations, audio, video, and performance works. He completed his MFA in new media at the University of Calgary and has presented his work and theories in over twenty lectures and public presentations. He has been the recipient of several grants and awards both nationally and locally. He has also invested a considerable part of his career in the community, having been both a co-director of Truck Gallery and photography facilitator at the Banff Centre, as well as sitting on several boards.

Philip P. Langill is associate professor (teaching) in the Department of Physics and Astronomy at the University of Calgary and was appointed director of the Rothney Astrophysical Observatory in 2006. He teaches physics and astrophysics and has received numerous awards, including the Students' Union Teaching Excellence Award and the Faculty of Science's Award for Community Engagement (Established Career category). He is currently the honorary president of the Royal Astronomical Society's Calgary Centre. He is a strong advocate for the preservation of naturally dark skies at night and strives to incorporate Indigenous perspectives into his teaching and outreach.

Elyse Longair is an artist, curator, and image theorist currently pursuing her PhD at Queen's University. Her research focuses on collage history, collage as research creation, and institutional strategies of collecting and curating collage. Among recent awards, she studied collage in Paris at the Centre Pompidou thanks to the David Edney Research Award, and was awarded the Exposure Emerging Photographer of the Year Award by Exposure Photography Festival, earning her a solo exhibition at Contemporary Calgary. Longair's "simple image" theory in collage reimagines the role of images away from the overt complexity that dominates our world, opening up new possibilities for imagined futures.

Hilding Neilson is an astrophysicist and assistant professor at Memorial University of Newfoundland and Labrador, where he works on the intersections of stellar and exoplanet astrophysics, the search for life in our galaxy, and Indigenous methods or ways of knowing. More specifically, he studies variable stars and exoplanet host stars to understand their physical properties. He then weaves traditional Western science and Indigenous methods to understand biological and technological signatures of extraterrestrial life to consider if and how astronomers should search for life. Dr. Neilson is Mi'kmaq and a member of the Qalipu First Nation in Newfoundland.

Chris Pak is a lecturer in contemporary writing and digital cultures at Swansea University, Wales. He is an award-winning literary scholar whose research into science fiction and climate change investigates how anticipatory narratives inform the climate imaginaries of the past, present, and future. He has published on geoengineering and terraforming (the adaptation of planetary environments) in science fiction and its relationship to contemporary science, policy, and activism. His book *Terraforming: Ecopolitical Transformations and Environmentalism in Science Fiction* (Liverpool University Press, 2016) is available online via open access. He is currently working on projects about science fiction and biophilic design.

Naomi Potter has been the director/curator of Esker Foundation in Calgary since 2012. From 2009 to 2011, she was curator of Walter Phillips Gallery at the Banff Centre. She has been a jury member for numerous Canadian art awards, including the Curatorial Selection Committee for Venice 2019. She currently sits on the Advisory Board of the Calgary Institute for the Humanities at the University of Calgary, and is a member of the Gail and Stephen A. Jarislowsky Outstanding Artist Program Committee at the Banff Centre. Potter holds a BFA from the University of British Columbia, Vancouver, and an MFA in sculpture from Concordia University, Montreal.

Keith Sidwell is emeritus professor of Greek and Latin at University College Cork and adjunct professor of Classics at the University of Calgary. His books include *Lucian: Chattering Courtesans and Other Sardonic Sketches* (Penguin, 2004); *Aristophanes the Democrat: The Politics of Satirical Comedy during the Peloponnesian War* (Cambridge University Press, 2009); *The Tipperary Hero: Dermot O'Meara's Ormonius (1615)* (Brepols, 2011), with David Edwards; *Poema de Hibernia: A Jacobite Epic on the Williamite Wars* (Irish Manuscripts Commission, 2018), with Pádraig Lenihan; and *Lucianus Samosatensis, Catalogus Translationum et Commentariorum* vols. 13 and 14 (Pontifical Institute of Mediaeval Studies, forthcoming 2025). He has just completed a monograph on Lucian entitled *The Witty Philosopher: Lucian and the Serio-Comic*.

Dr Robert Thirsk has academic backgrounds in mechanical engineering, medicine, and business administration. He has flown on two space missions as a member of the Canadian Space Agency's Astronaut Corps. Bob first flew aboard the space shuttle Columbia in 1996 as part of the Life and Microgravity Spacelab mission. His second flight, in 2009, was a six-month expedition aboard the International Space Station. Bob and his station crewmates performed multidisciplinary research, robotic operations, and maintenance of spacecraft systems and payloads. Bob continues to be a strong promoter of a national economy based upon exploration, innovation, and lifelong learning.

Nancy Tousley, recipient of the Governor General's Award for Visual and Media Arts, is a nationally known senior art critic, arts journalist, and independent curator. Born in the United States, she held curatorial positions at the Brooklyn Museum and the Art Gallery of Ontario before moving to Calgary, where she was the art critic and an editor at the *Calgary Herald* for thirty years. She has written essays for more than sixty public art gallery and museum catalogues and books. Her feature writing and reviews have appeared in magazines such as *ArtsCanada, Vanguard, Parachute, Canadian Art*, and *Border Crossings*.